PUMPKINING

A Story of Pumpkin and Melon Carving

Hugh McMahon

with

Michelle Kubota

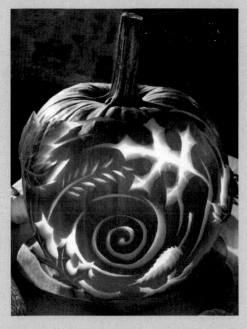

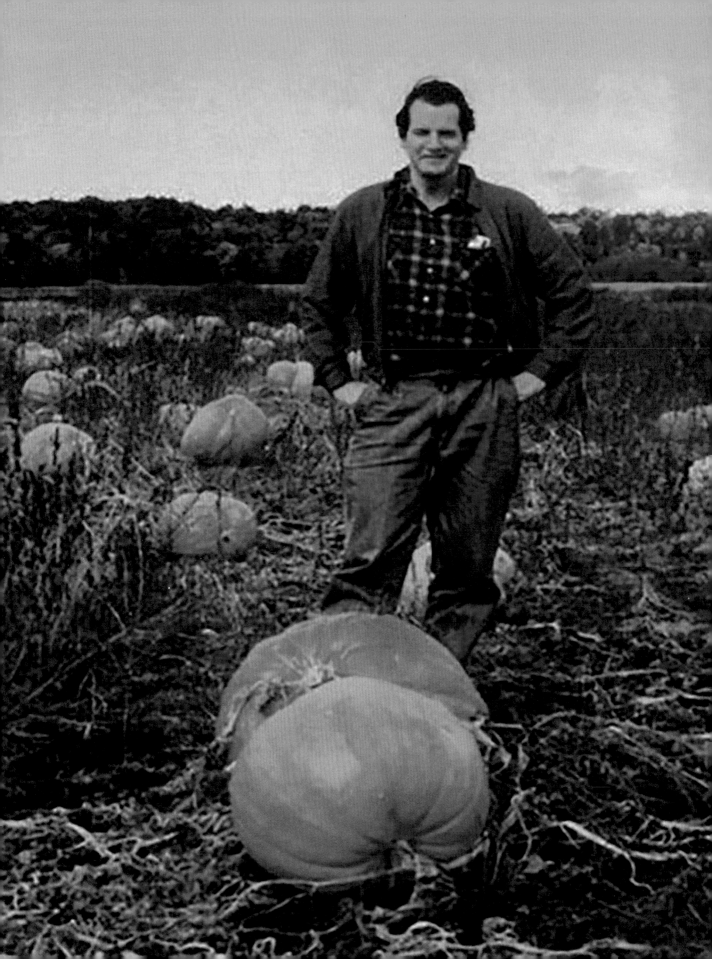

In a patch of time

There is a web of vines,

forming lines.

It's the October horizon

more defined

It's that intertwining fact,

Jack is coming back.

It's about our hidden belief

life returns

In many forms.

One of them is orange.

We look and smile

at that underlying fact,

Jack is coming back.

Hugh McMahon

This book is dedicated to my fellow pumpkin carvers for their creative contributions over many years.

John Hatelberg, Dylan Lubetkin, Lance Rutledge, Ray Carter, Kristin Hatelberg, Currin Hatelberg, Manuel Roman, Vincent, Frank Traynor, Jon Wang, Hannah, Edmund and Ruth McCarthy, Billy Quinn, Ron Crawford, WF McMahon, Michael McMahon, Elise McMahon, Meryl McMahon, Lilli Herrera, Michael Micali, Roberto Alfalla, Sarah Means, Cal Thomas, Duane Couture, and Jonah.

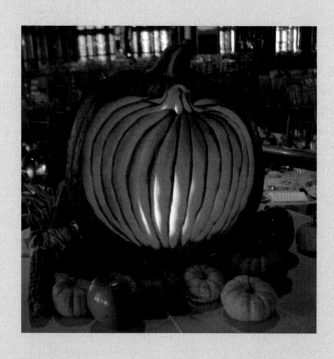

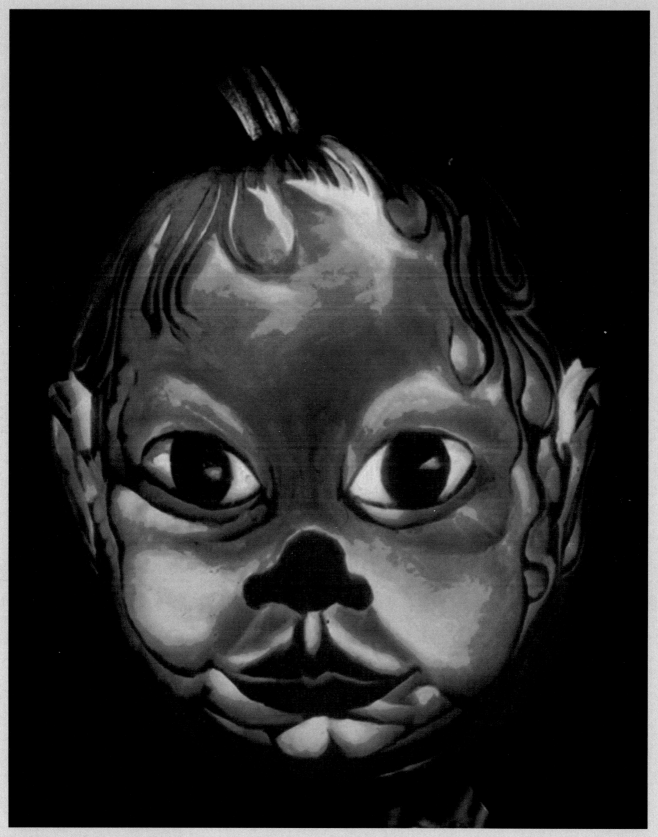

"Nora," A First Birthday

The Beginning

Early in my pumpkin carving career, I would carve a pumpkin, place in a black plastic bag and carry it on my back from restaurant to restaurant until it sold. One dark, damp October night I was on the upper east side of New York City walking the rounds. I was turned down at Maxwell Plum, Adams Rib, and Catch A Rising Star.

Discouraged, wiping drizzle off my face, I looked up and saw a sign, "Ichabod's." I walked in and asked, "Is this place named after Ichabod Crane?" "Yes," responded the hostess." "I think I have come to the right place," as I lifted the bag off my shoulder. "I think you have," she quipped, not knowing what the black bag concealed.

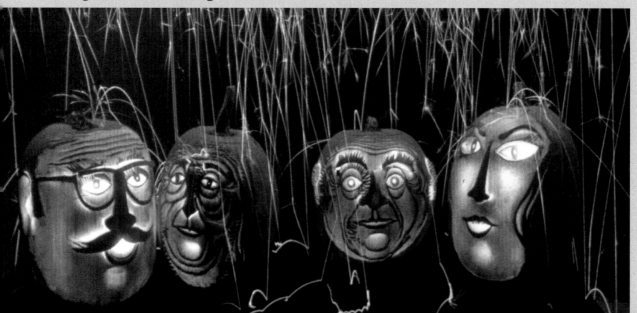

Photo: Dean Chamberlain Soho News

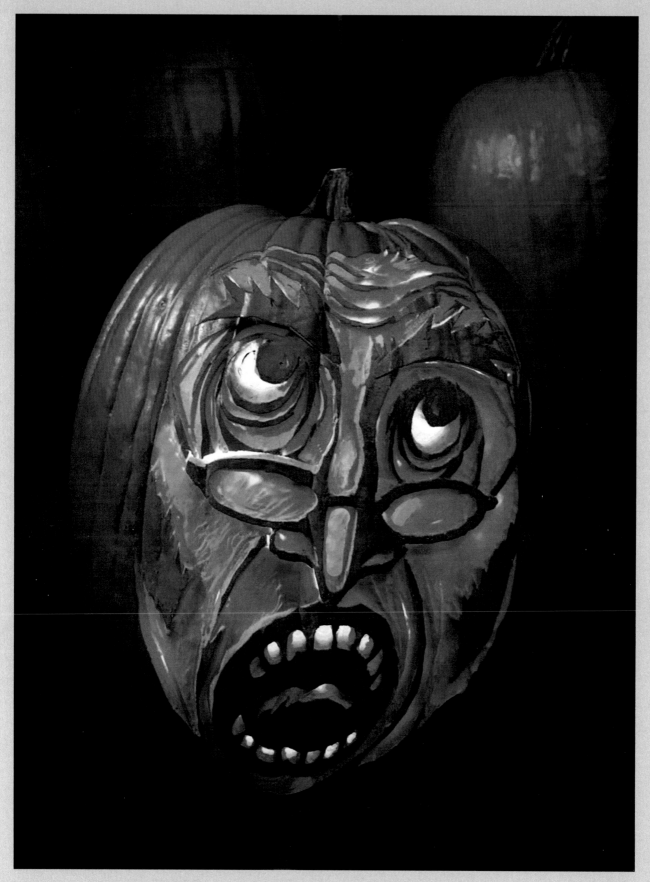

Ichabod Crane, Ripples Believe it or Not, New York City

Auld Lang Syne

Samhain is the Celtic festival marking the end of harvest and winter's beginning. Its where pumpkin and gourd carving originated. The Celts of Europe hollowed out turnips and rutabagas, preparing the candlelit jack-o'-lanterns.

When the Celtic people came to America, they discovered the larger orange pumpkin which Native Americans had cultivated for thousands of years. The Celts bought other Halloween customs with them, wearing costumes around the bonfire, skulls, witches and begging for treats. On Halloween night, they believed ancestors rise from their graves.

Green men are Celtic motifs which appear in European medieval gothic architecture. The tree worship tradition takes shape as a leaf face.

Leaf Devil

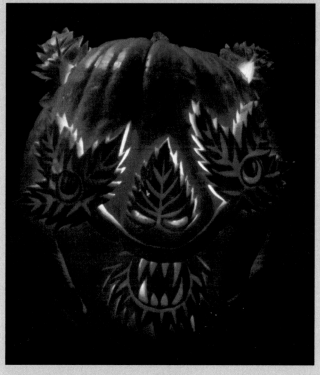

Leaf Bear

Leaf Tiger

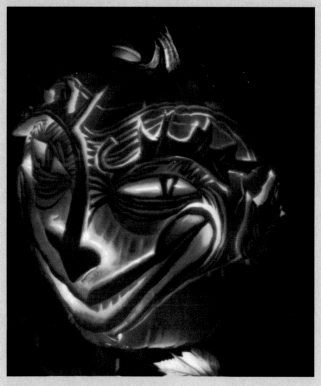

Leaf Devil

Join the Club

In 1976, Studio 54 was one of my first clients for pumpkin carving. It was a cold call, buzzing their back door. A man opens and sticks out his head. "I'm a pumpkin carver," I announced.

Subsequently, I went on to carve for the Palladium, Red Parrot, Moxy, Roxy, Area, Lot 61, Cheetah, Kit Kat Klub, Amazon, Latin Quarter, Scores, TAO, LAVO, Rose Bar, Electric Room, Dream Hotel, Copacabana, Radio, Marquee, Lotus, and many other very late nights.

Palladium

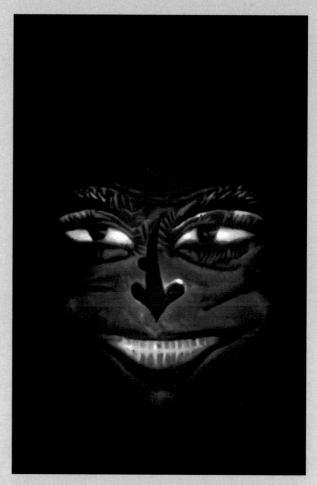

Red Parrot

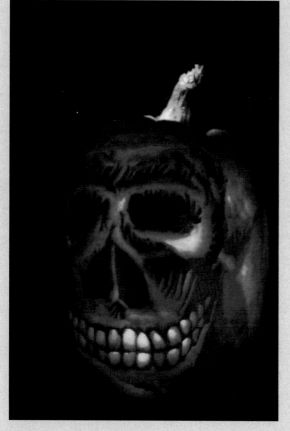

Studio 54

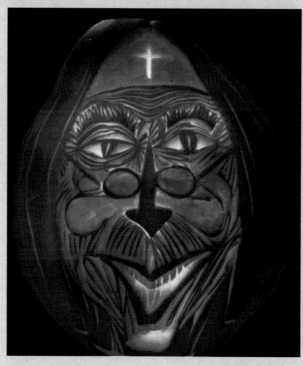

Palladium

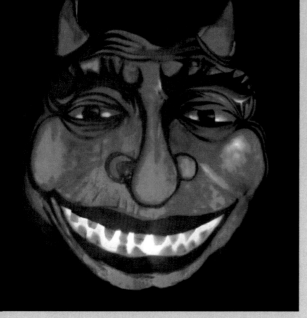

LAVO

TAO

LAVO

TAO

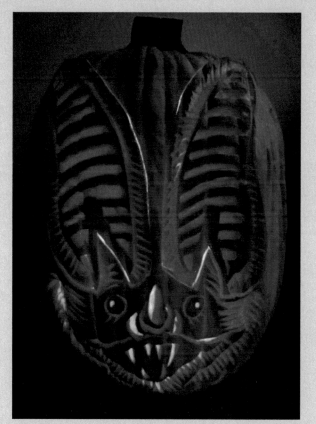

TAO

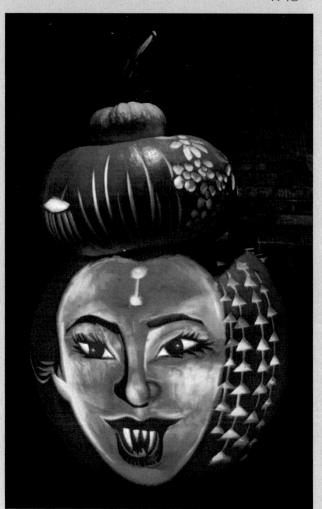

TAO

LAVO

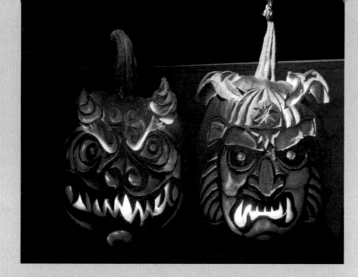

TAO

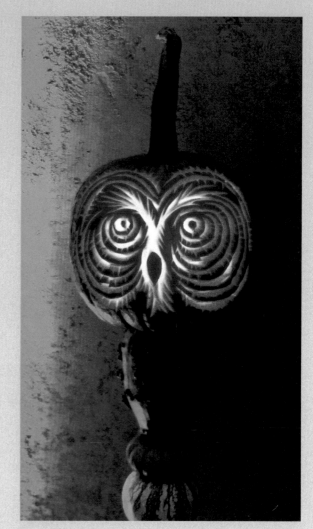

Vandals

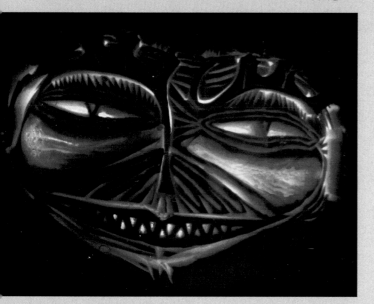

Dream Hotel

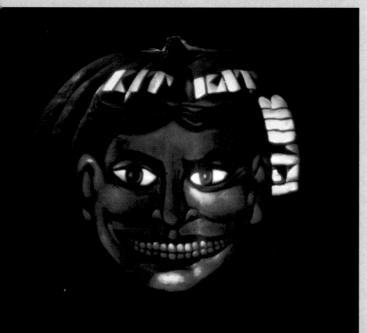

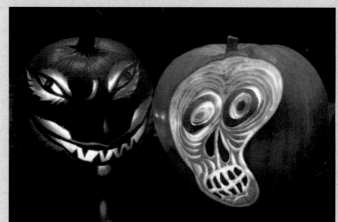

LAVO

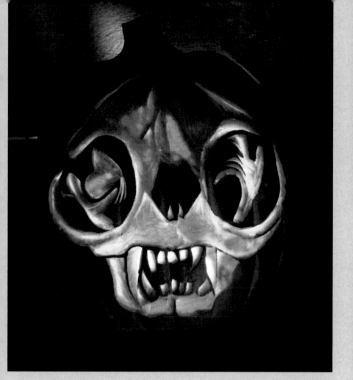

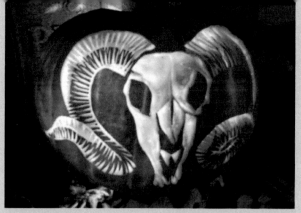

Cheetah Club

Moxy

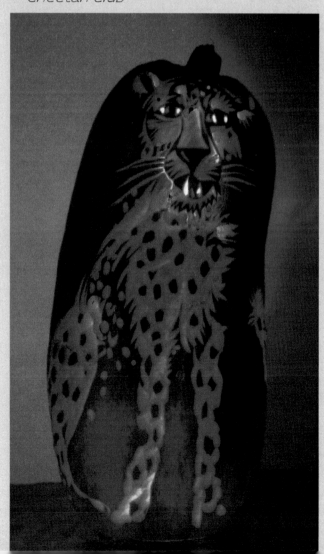

TAO

TAO

Vandals

The Vultures

My first vultures were for the Whitney Museum's 65th Anniversary Benefit. As guests entered the building they were greeted by two vultures sizing them up for dinner.

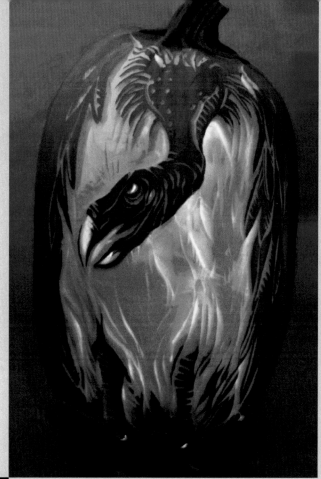

The Electric Room

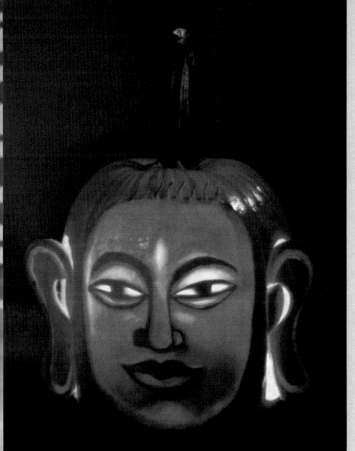

The Buddha

I carved a series of Asian images for the Lot 61 Fashion Week party; the Buddha was one of those.

Lot 61

13

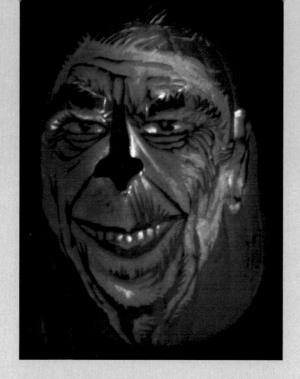

White, Red and Blues

This pumpkin portrait of Ronald Reagan was published in People Magazine. Soon afterward, I received a call which led to me carving a large turkey pumpkin for the Reagan's White House Thanksgiving.

When I arrived at the Pennsylvania Avenue gate, the bulky black bag did not fit through the metal detector. A security dog brought over to smell the bag could not sense past the pumpkin. Eventually, the guard opened the bag to look inside the cumbersome hollowed-out pumpkin.

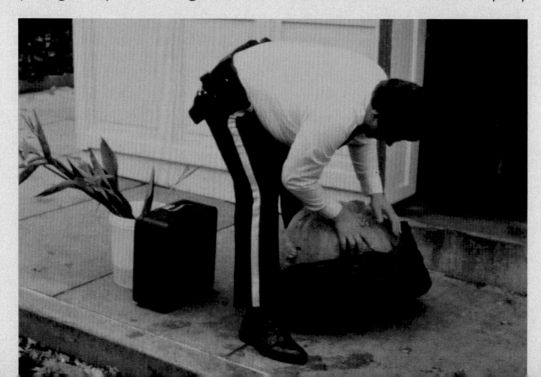

Walter Mondale and Ronald Reagan

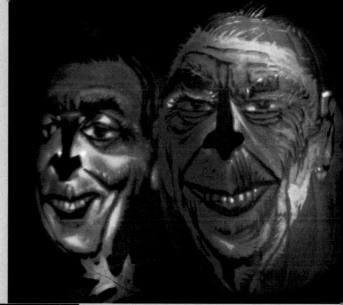

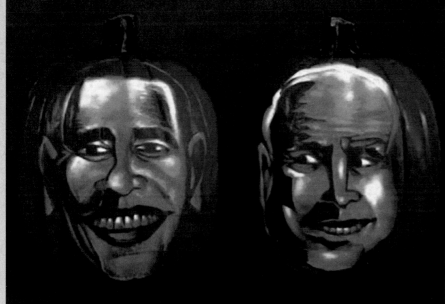

Barack Obama and John McCain

Hillary Clinton and Donald Trump

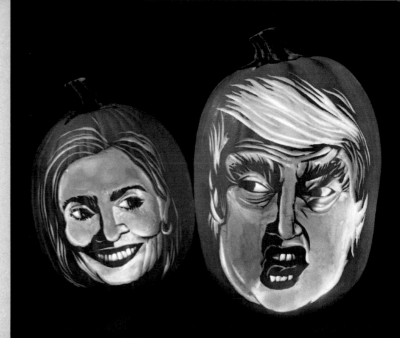

"A Place Called Hope"

This was a Bill Clinton campaign slogan. Clinton said of the two sons of Hope, Arkansas, "It doesn't matter what (Mike) Huckabee and I accomplish in life, we will always rate third at best in Hope, behind watermelons and Bowie knives."

The capital of huge watermelons, the leading growers, were Ivan Bright and his family. His family produced a Guinness record-breaking 268.8-pound watermelon at the 2005 Hope Watermelon Festival.

Ivan Bright Carving sponsored by CBS This Morning, TV.

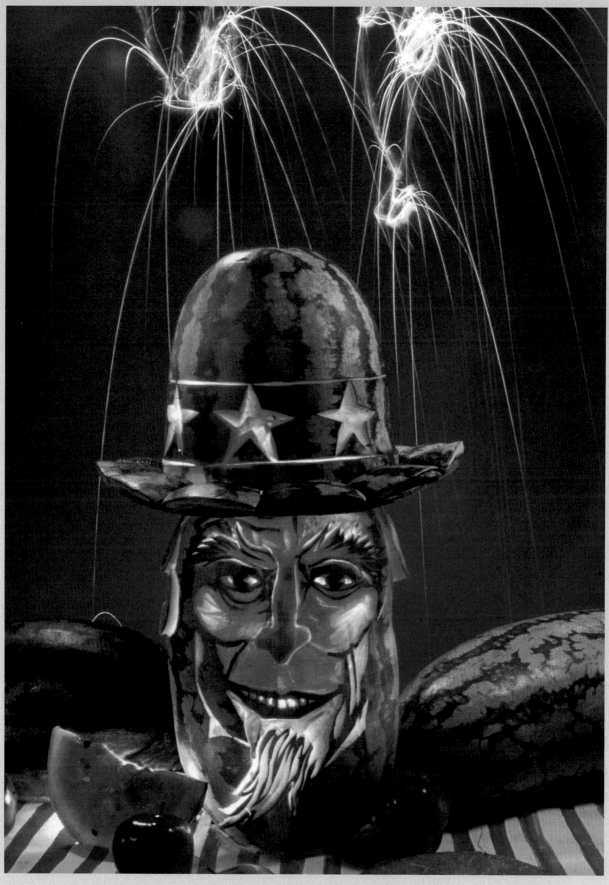

Uncle Sam

Kids for Kids

During the 1990's, I was carving for the Elizabeth Glaser's Pediatric Aids Foundation benefit. The sponsor was Vanity Fair Magazine. One-year Hillary Clinton attended. I was asked to carve a one-hundred-and-fifty-pound pumpkin portrait of her. Afterward, Hillary sent me a nice note complimenting the work.

A few years later, Time Magazine hired me to carve portraits of Hillary and Newt Gingrich. At the time, Hillary was running for the New York Senate, and Newt was losing his job as Speaker of the House due to misconduct. They had finished their national health care fight. Never knew if she saw these carvings, Spooky!

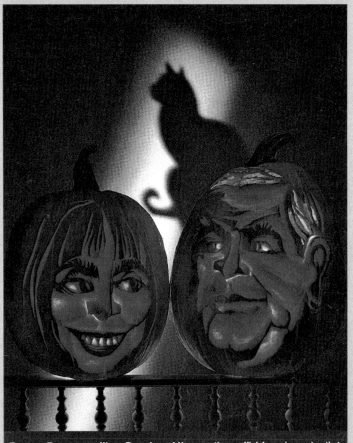

Photo: Ted Thai

TRICK OR TRICK OF THE WEEK: Boogabooga! Here are the unofficial running mates that go bump in the night. The G.O.P. says a vote for Bill is a vote for Hillary the hobgoblin; the Dems scare the children with Newt Gingrich. Spooky, spooky.

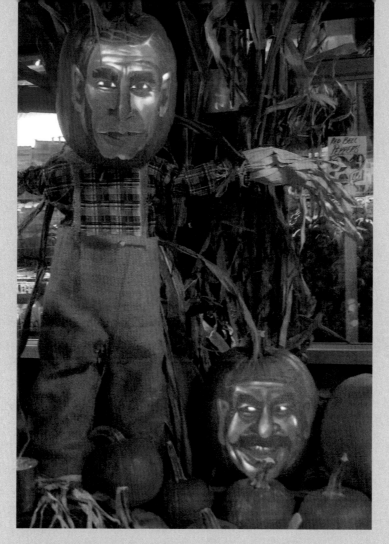

George W. Bush scarecrow, with Saddam Hussain, at the Chelsea Market in New York

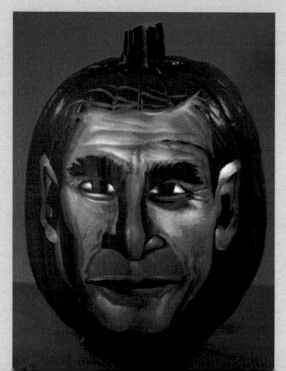

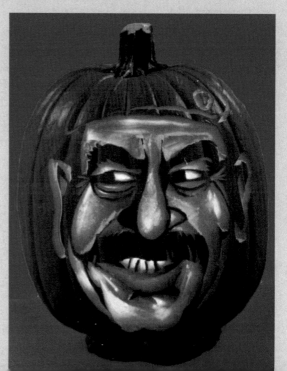

Giving Thanks

My ship came in as a Mayflower carving for the Rainbow Room's Thanksgiving. Cipriani, the Italian restaurant group, hired me to carve large pumpkin displays allowing me to explore a cornucopia of Thanksgiving themes. I also carved the Mayflower Ship in a 600-pound pumpkin for the Topsfield Fair in Massachusetts. The home state of the Plymouth Rock.

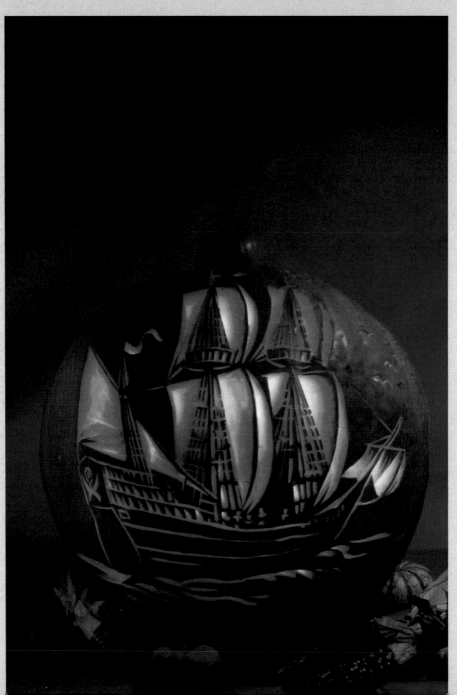

Rainbow Room

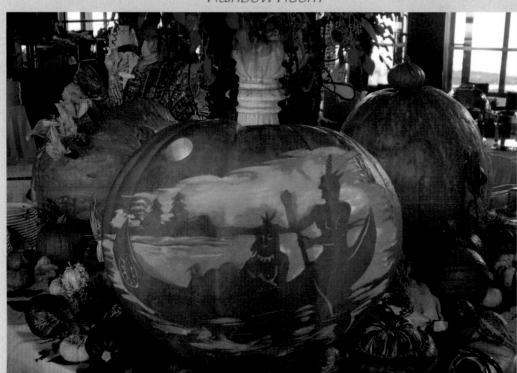

Rainbow Room

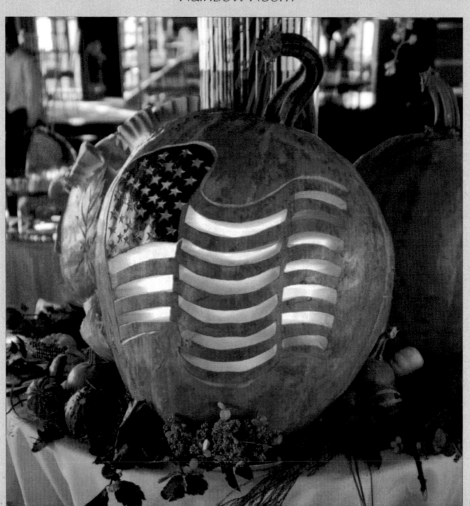

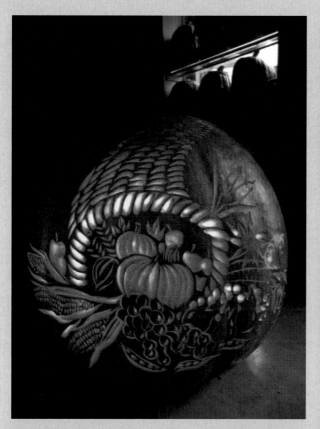

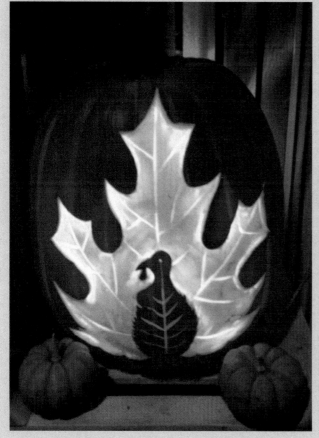

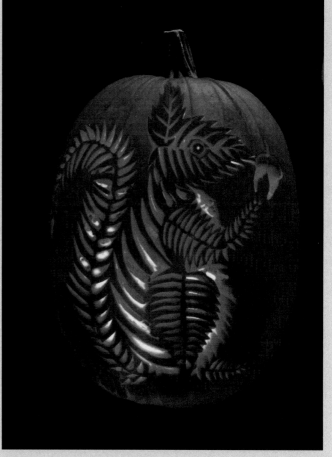

Chelsea Market

Plaza Hotel

23

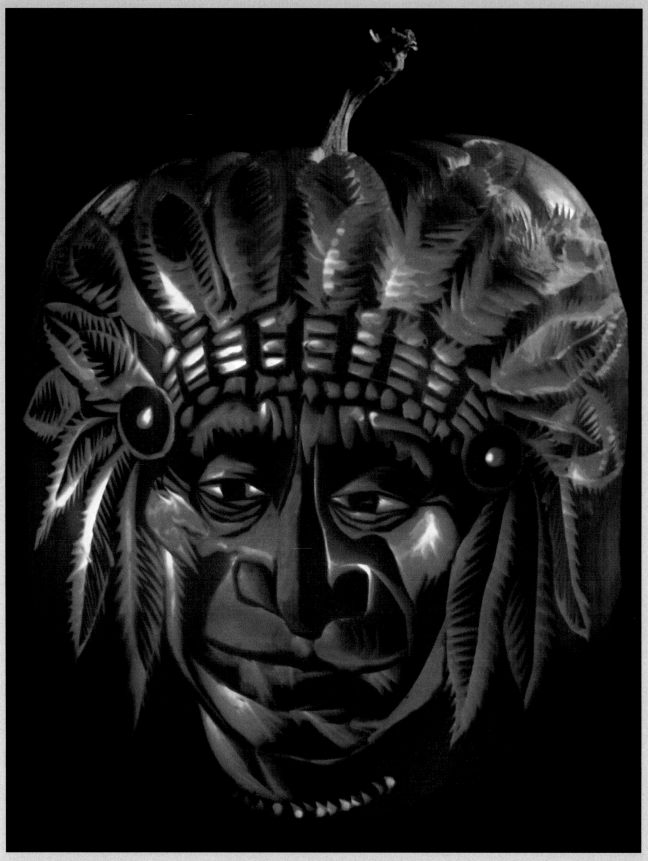

Chief Sitting Bull

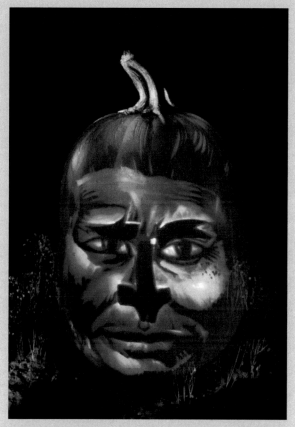

Chief Joseph

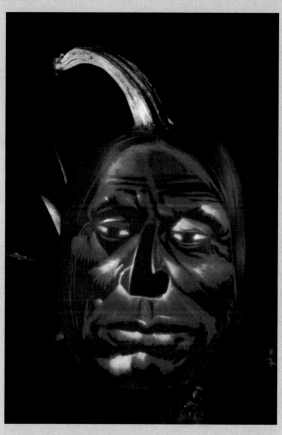

Chief Quanah Parker

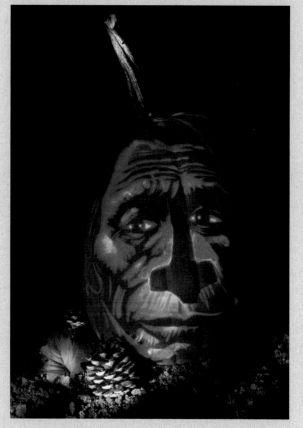

Chief Red Cloud

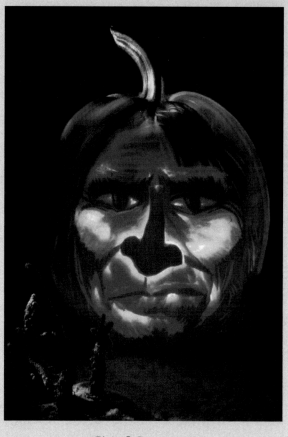

Chief Geronimo

25

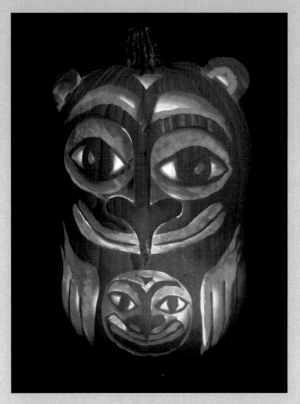

Private

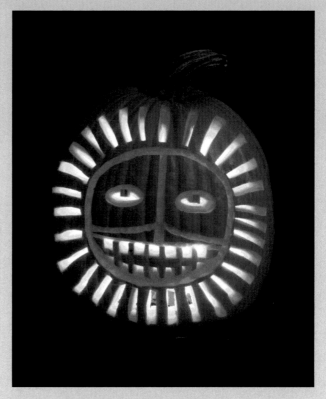

Private Thanksgiving

Chelsea Market

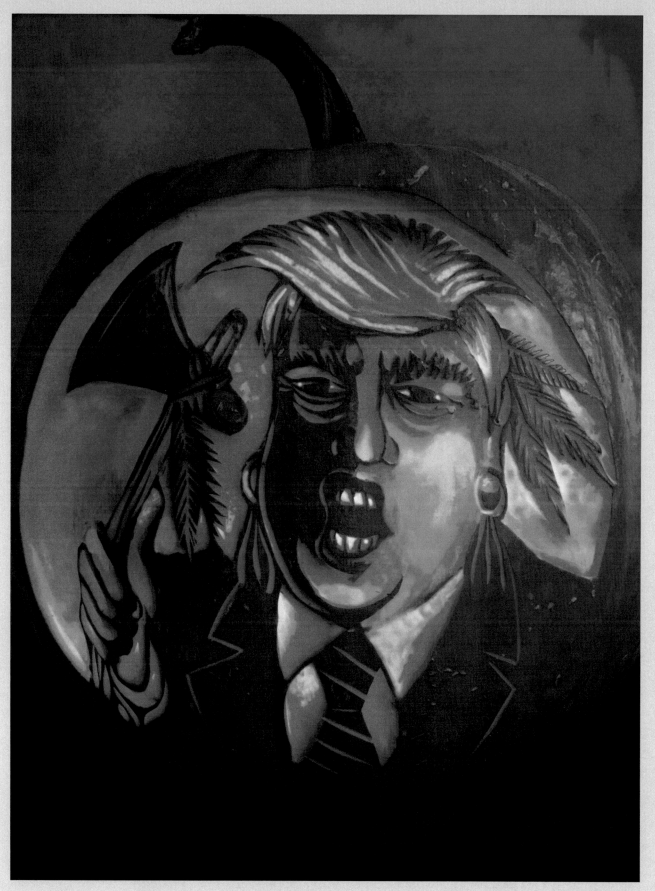

Nativist Trumpkin

Clearwater

The Clearwater Music Festival invited me up to the Hudson Valley, NY, to carve for troubadour Pete Seeger's 90th Birthday celebration. "This machine surrounds hate and forces it to surrender," is written on Seeger's Banjo.

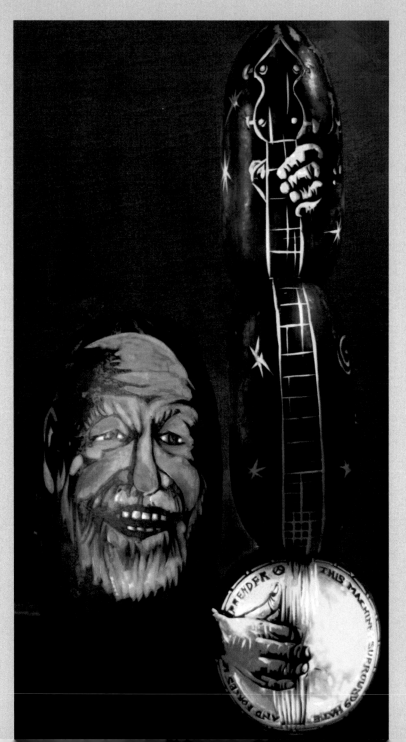

Bob Dylan

Woody Guthrie

Willie Nelson,

for Texas Monthly Magazine

Location

The Brooklyn Academy of Music (BAM) was throwing a benefit honoring New York real estate companies. I sold the special events department on doing melon carvings with the three rules of real estate, "location, location, location." The City of Brooklyn donated the cast iron lamp post.

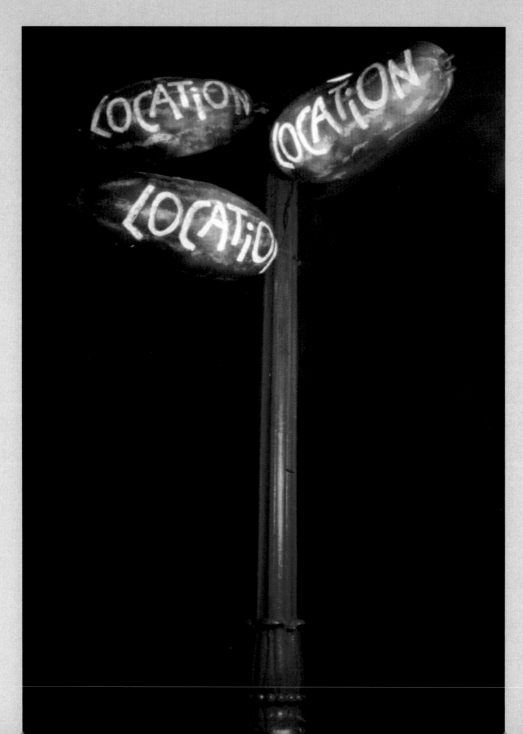

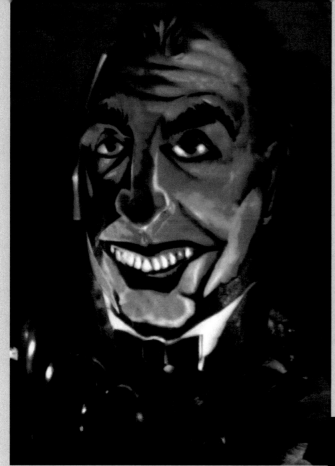

A watermelon portrait of Harvey Lichtenstein, the director of BAM, for his 35th Anniversary tribute party.

Mark Morris, Principal dancer, and choreographer of contemporary dance for BAM.

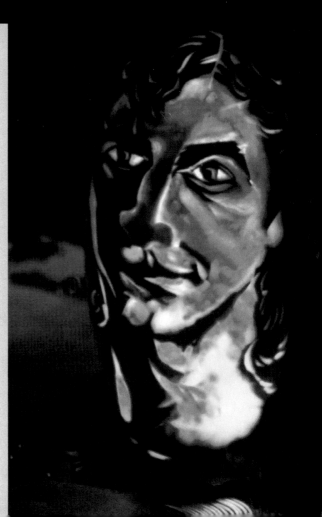

Carmen Miranda

Laurie Anderson and Arto Lindsay, the bossa nova musician, put together a tribute performance to Carmen Miranda. Jon Crow and I designed the invitation with a watermelon carving of Carmen on the beach of Rio de Janeiro.

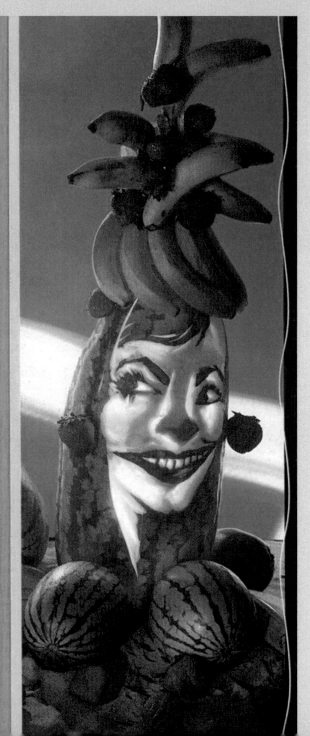

The Brooklyn Academy of Music's

We cordially invite you to attend
the 1991 NEXT WAVE Gala Benefit
Wednesday, October 23, 1991

BAM Opera House *30 Lafayette Avenue*

6:00 pm *Cocktails & Hors d'oeuvres*

7:00 pm

Carmen Miranda

Created and Directed by **Arto Lindsay**

with **Laurie Anderson**

and **Nana Vasconcelos**

featuring vocalists **Elza Soares, Bebel Gilberto,
and others**

Costumes by **Nicole Miller**

*Immediately Following the Performance
Join Us on the Road to Rio for Supper and Samba*
BAM Majestic Theater *651 Fulton Street*

RSVP *Card Enclosed* **Festival Attire** *718.636.4182*

*CARMEN MIRANDA was conceived by Verna Gillis,
commissioned by the Brooklyn Academy of Music
and co-produced with Verna Gillis/Soundscape.*

Image Courtesy of BAM Hamm Archives

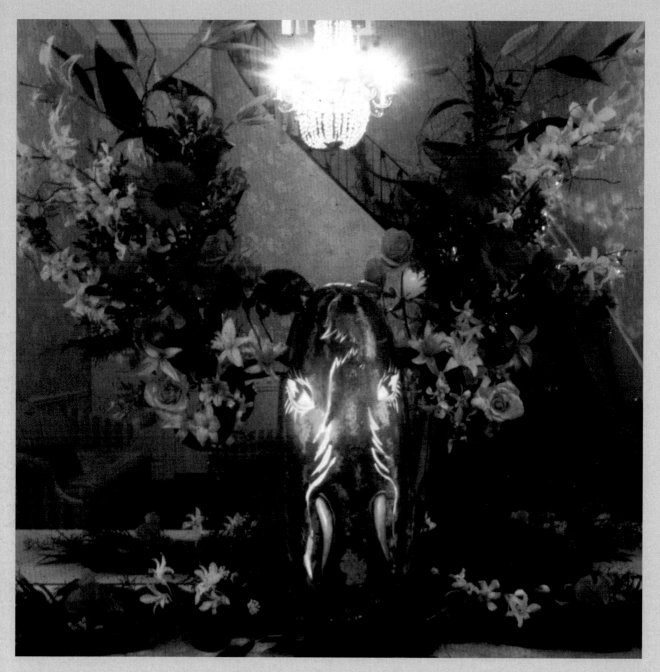

Moose

Harvey Lichtenstein hired me for his mother-in-law's birthday. Her nickname was Moose. My job was to "put lipstick on a moose." I settled on carving a moose head and designed an armature as antlers that would hold a vast bouquet of flowers. It was a big hit!

Home Shows

I was traveling the country carving for home and craft shows. In 2003, I was sculpting in California when Arnold Schwarzenegger was running for Governor. In San Francisco, I carved a watermelon portrait of Arnold for a TV shoot on San Francisco Golf Course with former Mayor, Willie Brown. Driving away from the shoot I hit a speed bump, and the portrait broke in the trunk. At the Santa Cruz Show, like Humpty Dumpty, I tooth-picked the portrait together, just in time for the second TV shoot.

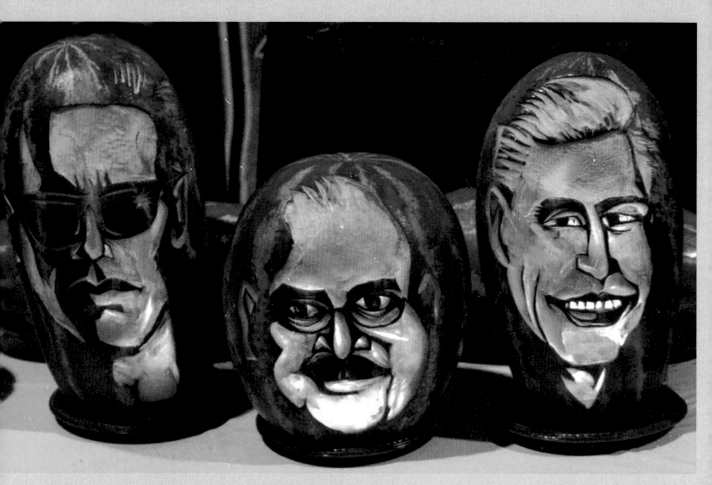

Arnold Schwarzenegger *Cruz Bustamante* *Gray Davis*

California Governor candidates in the recall election

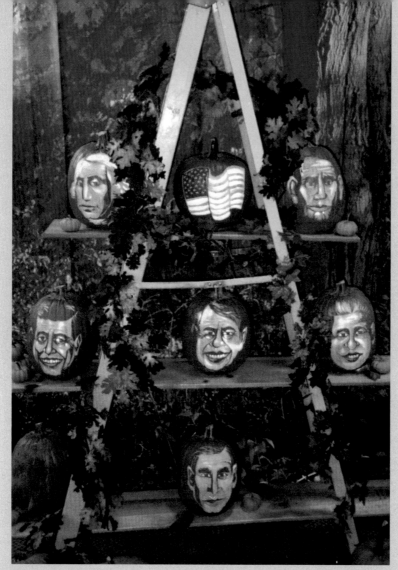

Capital Home Show in Chantilly, Virginia

Topsfield

The Topsfield Fair is the oldest country fair in the United States at 200 years old. The Topsfield Fair has the most massive pumpkin weigh-in for giant pumpkins. Some of these pumpkins have grown to over two thousand pounds. Libby's Pumpkin Pie and Toyota sponsored me to demonstrate carving these monster pumpkins during the weigh-in competition.

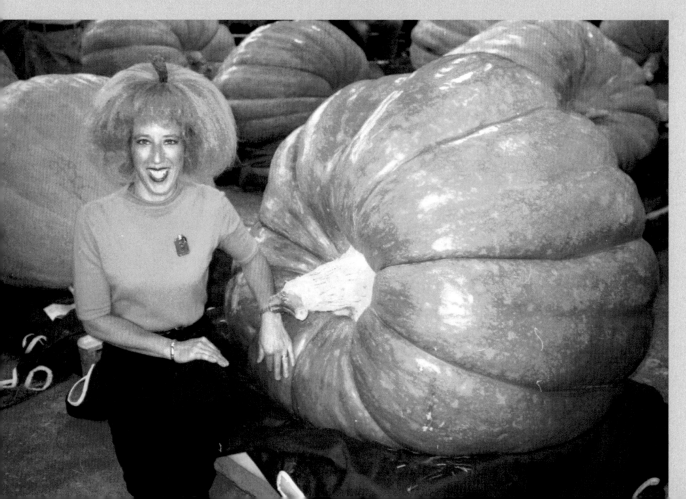

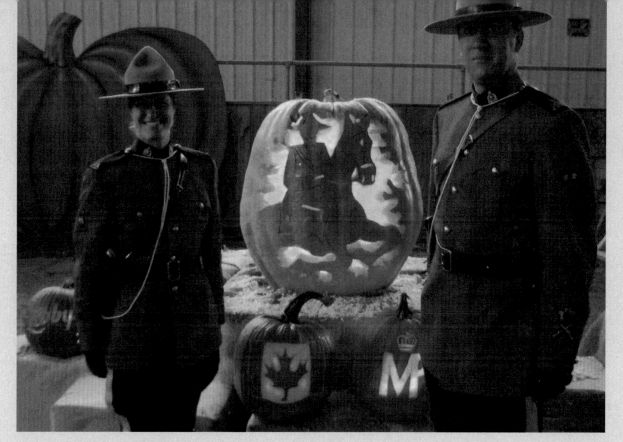

"Canadian Mounties," 300-pound pumpkin, Topsfield Fair

"Bull," 500-pound pumpkin, Topsfield Fair

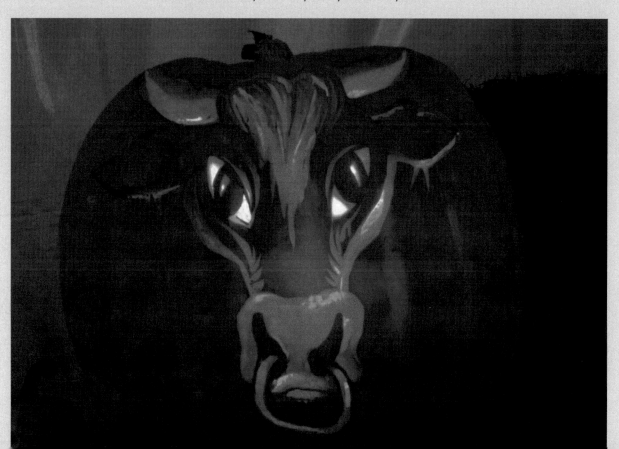

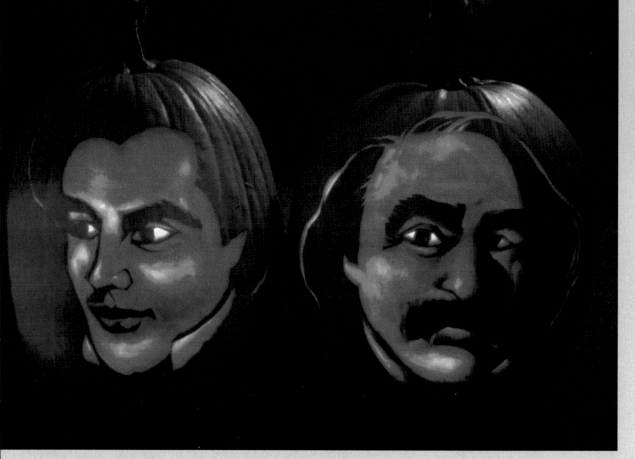

Writer, Nathaniel Hawthorne, young and old, for the City of Salem, MA

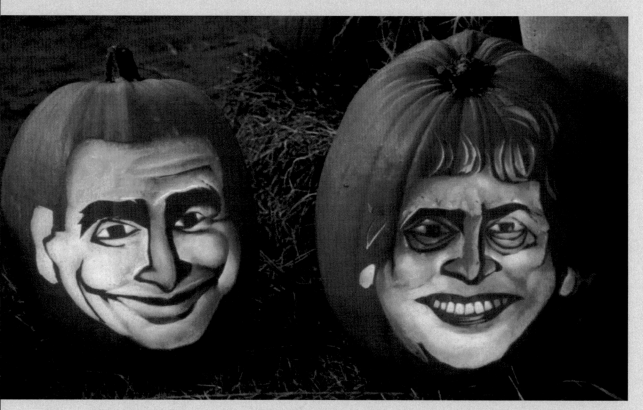

Emeril Lagasse and Julia Childs, both born and raised in New England, Topsfield Fair

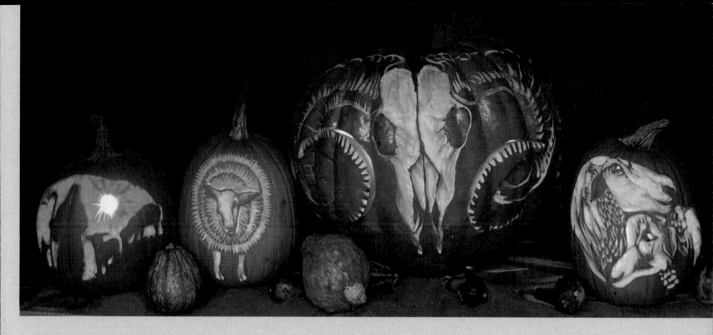

Bob Grems, from Dutchess Wool and Sheep Festival in Rhinebeck, NY saw my work at the Topsfield Fair and invited me to Rhinebeck. I carved pumpkins for the Wool and Sheep Festival and August watermelons for the Dutchess County Fair.

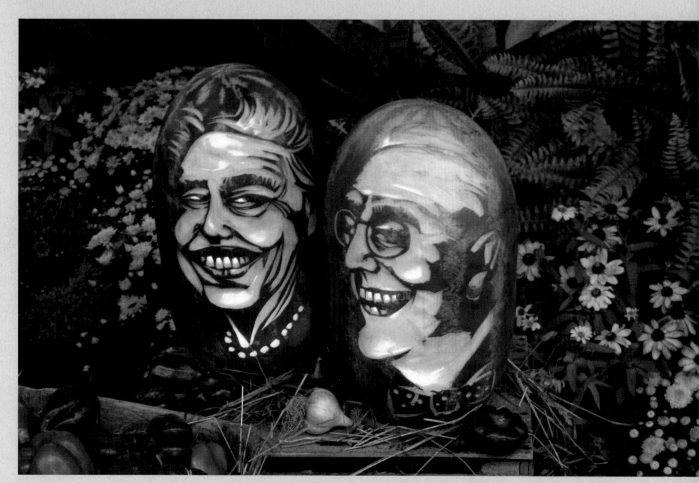

Eleanor and Franklin Roosevelt, historic neighbors in Hyde Park, NY

Circus Fans of America is a group that travels about to see the many different circuses.

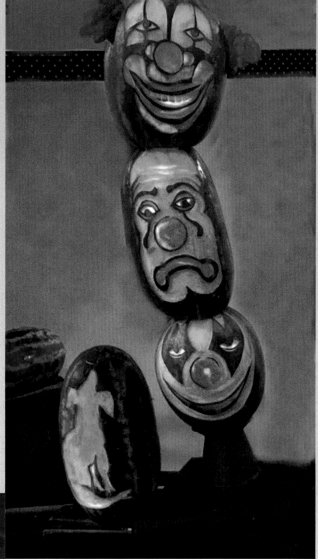

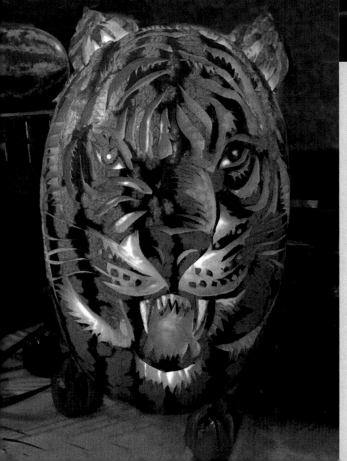

As visitors of the fair, Bob Grems asked me to carve some circus subjects.

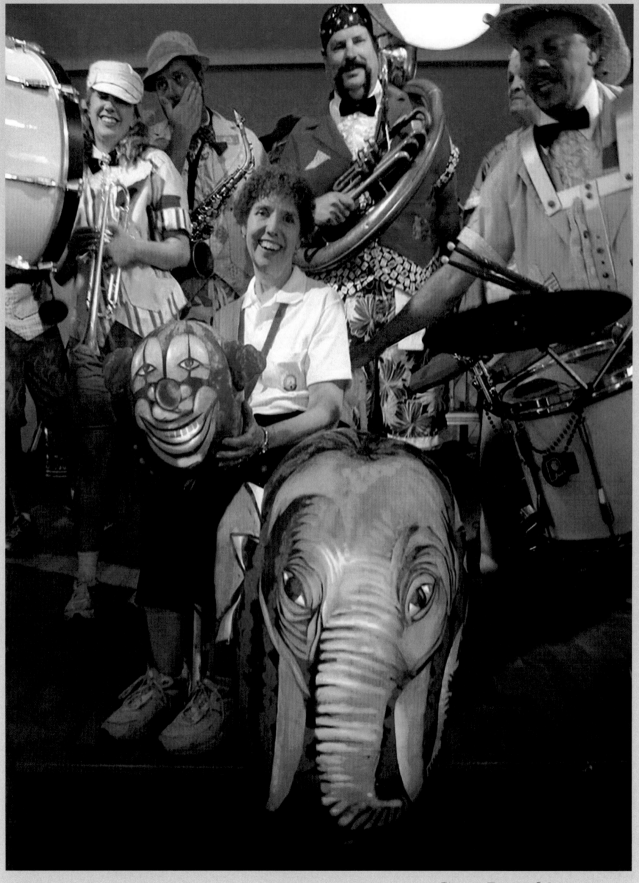

Circus Fans of America

Via word of mouth from Rhinebeck, these carvings are from the Bloomsburg Fair in Pennsylvania.

Benjamin Franklin

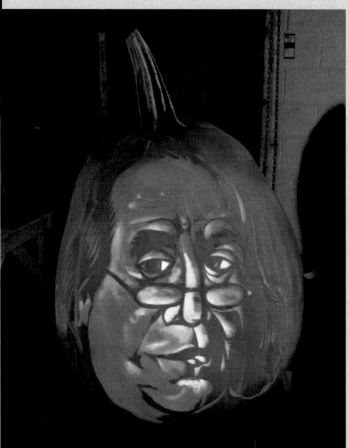

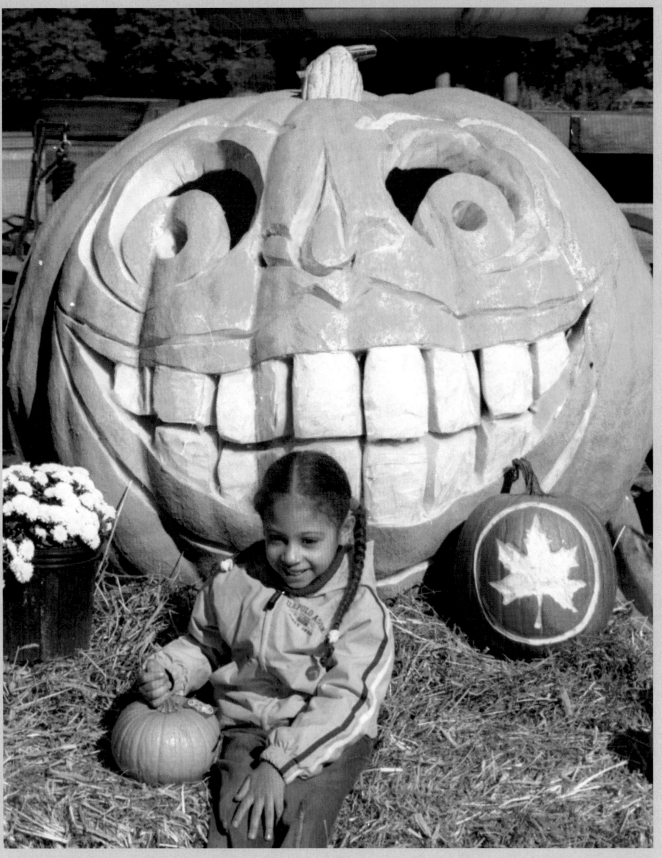

Central Park, New York City. The park commissioned me to broker large pumpkins from the Topsfield Fair for carvings.

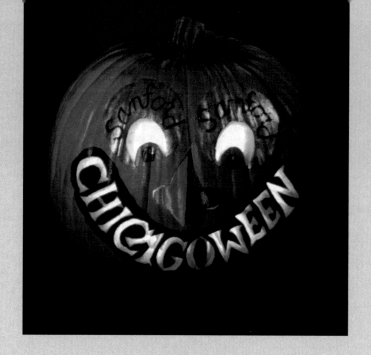

Chicagoween

I grew up in a suburb of Chicago. The city was beckoning me to return to carve pumpkins. The Sanford Company, makers of Sharpie markers and paints, commissioned me to carve and paint "funkins" (artificial pumpkins) for the City of Chicago. I developed a new style of sculpting for the Daley Plaza Haunted House. The pumpkins were presented by Mayor Richard Daley Jr.

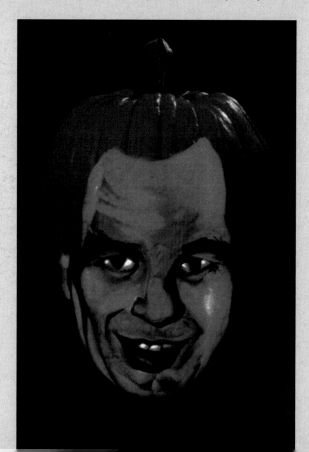

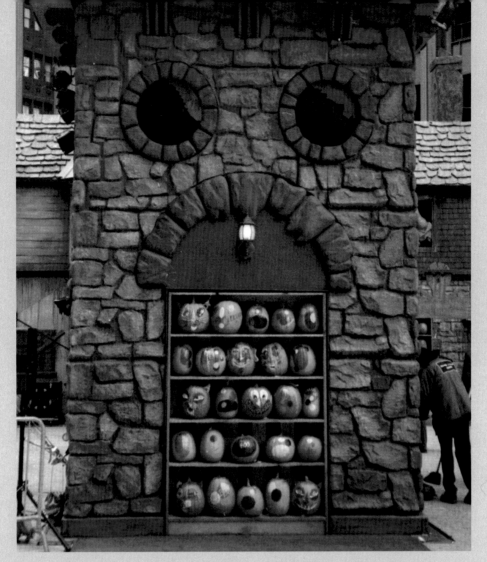

Painted Pumpkins, Daley Plaza Haunted House

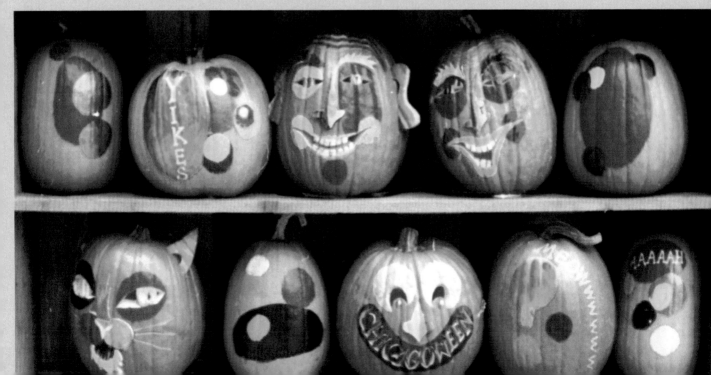

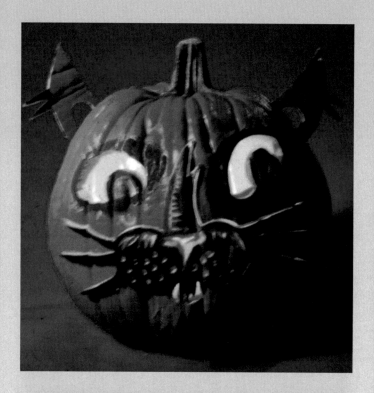

Painted Pumpkins for Sanford Company

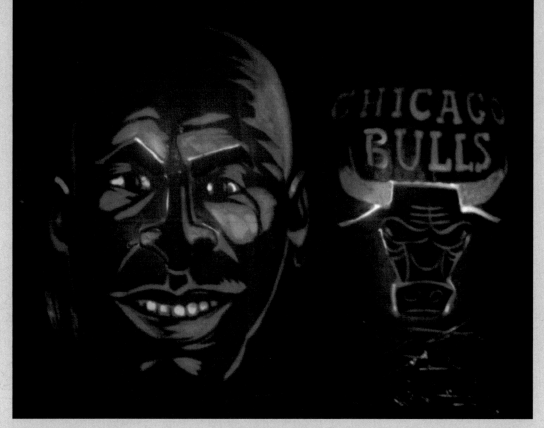

Michael Jordan, Chicago Bulls

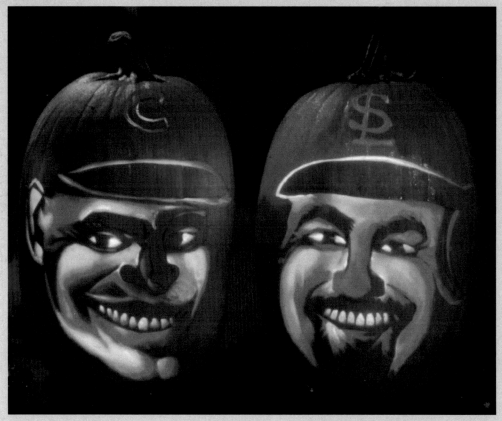

Sammy Sosa, Chicago Cubs and Mark McGwire, St. Louis Cardinals, homerun sluggers.

James Beard

In 1985, Chef Larry Forgione, of American Place Restaurant, hired me to carve a pumpkin portrait of his mentor Chef James Beard, to be gifted to Beard at a dinner.

James Beard fell ill, and Larry presented the portrait at the hospital. I went on to carve in melons and pumpkins many times for the James Beard Foundation, including the 100-year anniversary celebration at the James Beard Awards Gala.

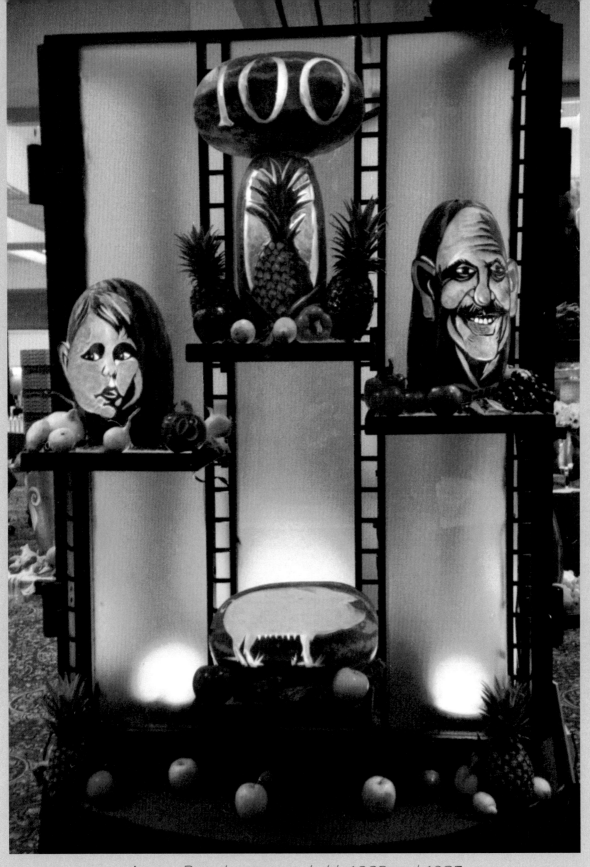

James Beard, young and old, 1903 and 1985

James Beard Foundation Awards

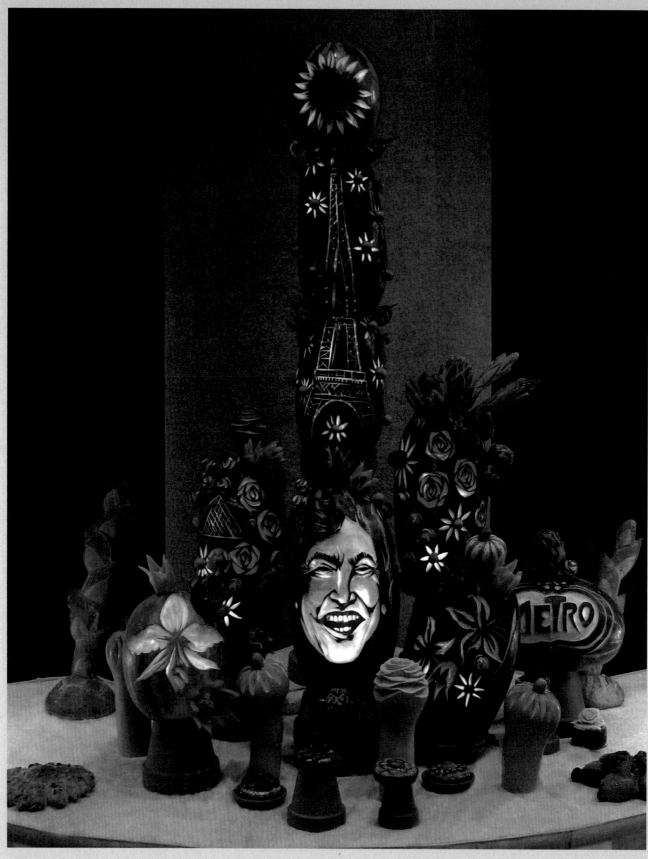

"Julia Childs in a Bouquet in Paris..." *A tribute carving*

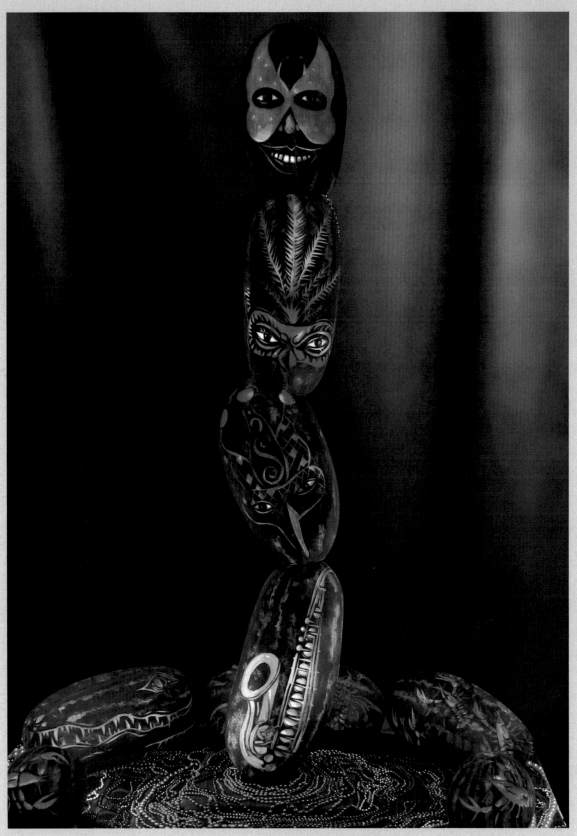

"Resurrection," a James Beard tribute to New Orleans after Hurricane Katrina

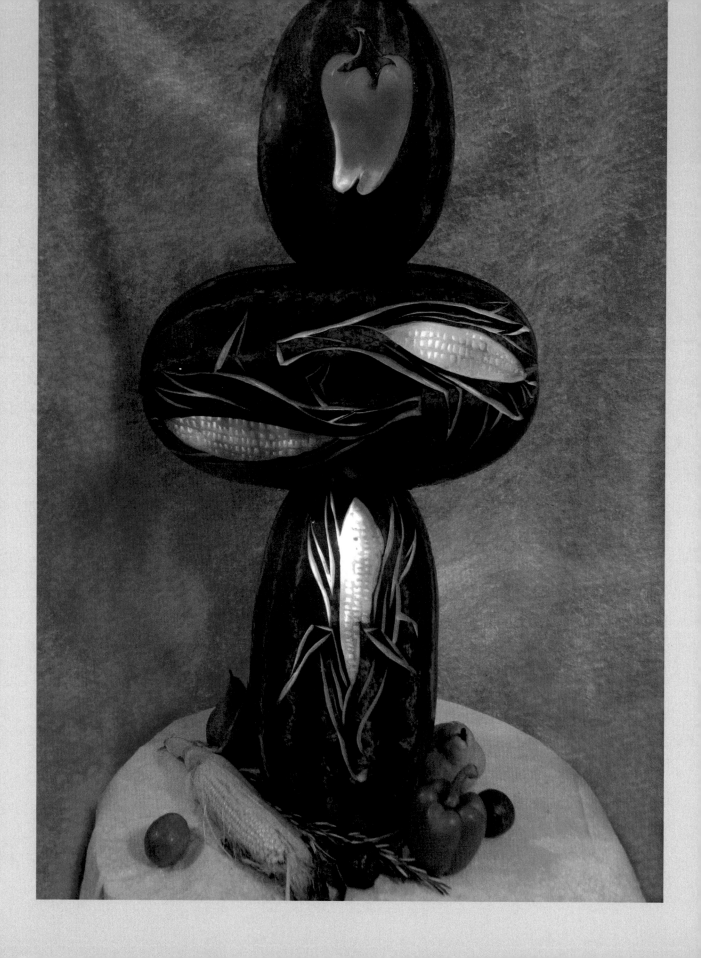

"Latin Sabor," James Beard's tribute to Latin cuisine

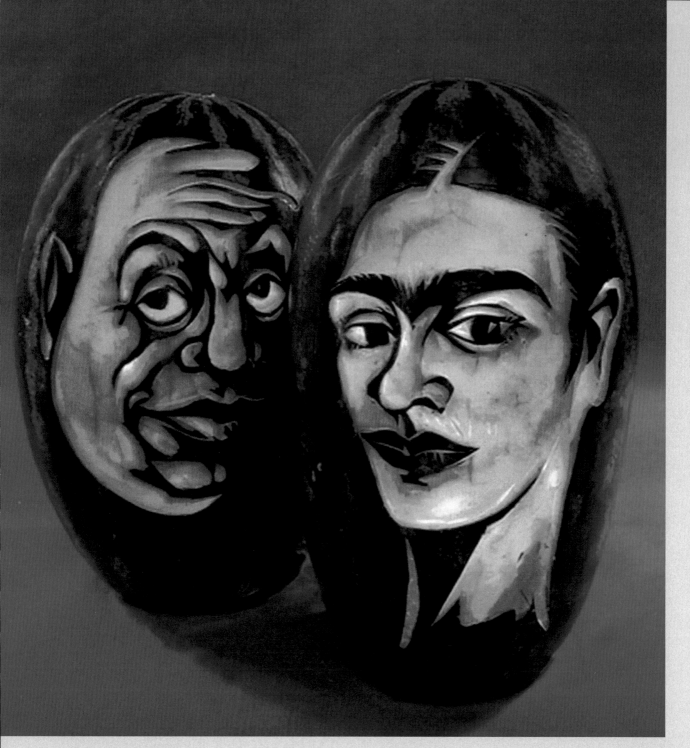

Latin Sabor

In 1954, Mexican Artist, Frida Kahlo passed away. Her last painting was a watermelon still life. Three years later, her husband, Diego Rivera passed. His final painting was a watermelon still-life. I carved this melon homage to that fact, and it was on display for Cinco de Mayo at the Chelsea Market.

Chef Arron Sanchez saw my work at the James Beard Awards leading to a series of collaborations.

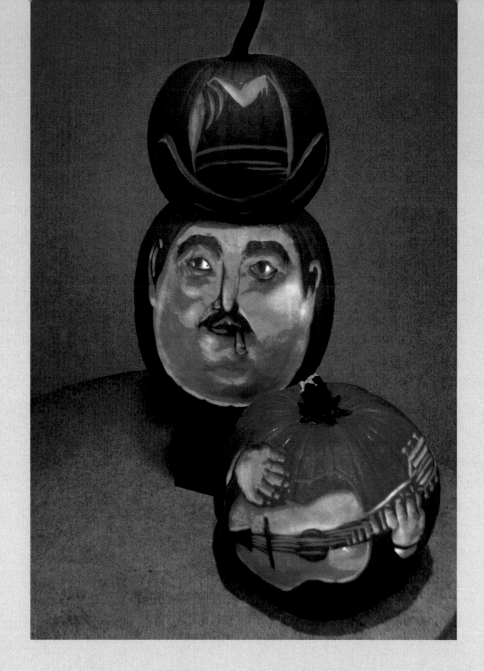

Boterismo

Fernando Botero, the Columbian artist, who has a peccadillo for painting people plumper than they are, a style described as "Borterismo." The New York City florist, L' Olivier Floral Atelier, hired me to carve for Botero's October birthday celebration.

We settled on representing some of Bortero's paintings, including his self-portrait, in huge 100 to 200-pound pumpkins. I heard after Olivier set up the carvings at Daniel's Restaurant, Bortero and his wife, artist Sophia Vari, arrived at the event and they cried in contentment.

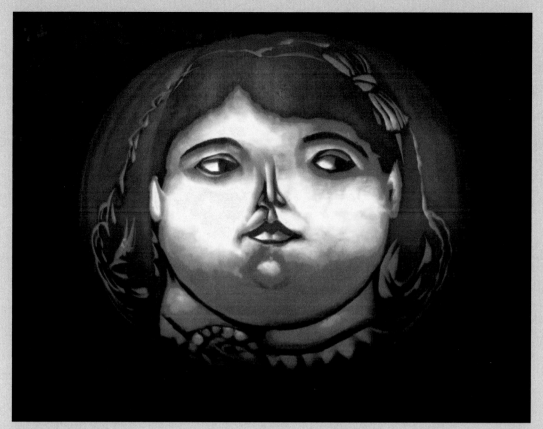

"Botero Girl," 200-pound pumpkin

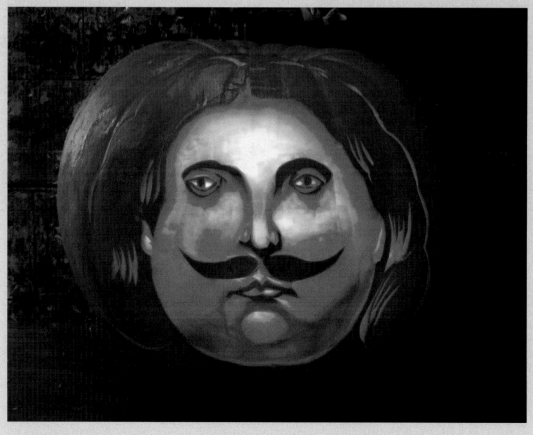

"Fernando Botero Self-portrait," 150-pound pumpkin

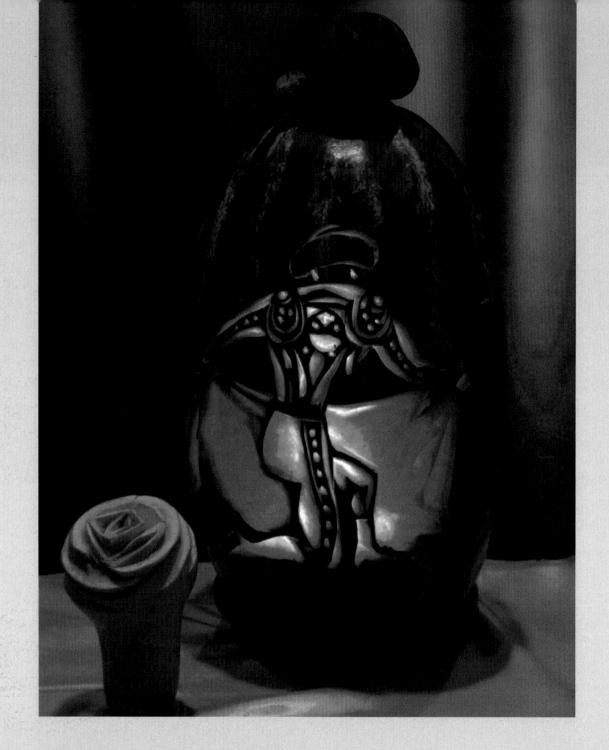

Torro Bravo

The Marriott Marquis in Time Square, New York had a corporate party for all the hotels. They hired me to carve this Spanish tapas bar of Torro, Ole!

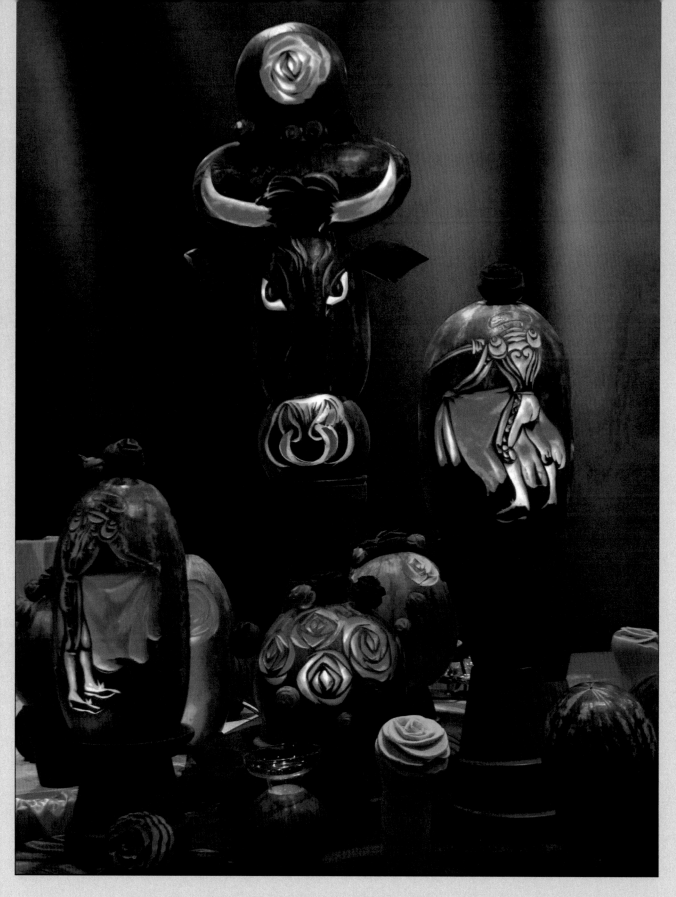

Torro, Marriott Marquis, Time Square, New York City

Chelsea Market

Off and on since 1998, I've had a studio at the Chelsea Market, NYC, also the home of the Food Network. The industrial-grunge-style food hall was a perfect fit within the Manhattan Fruit Exchange pumpkin patch. Over two decades, the market sponsored my displays of artificial ""funkins," and giant pumpkin carving. The most massive carving was a 1,662-pound pumpkin delivered from Ohio.

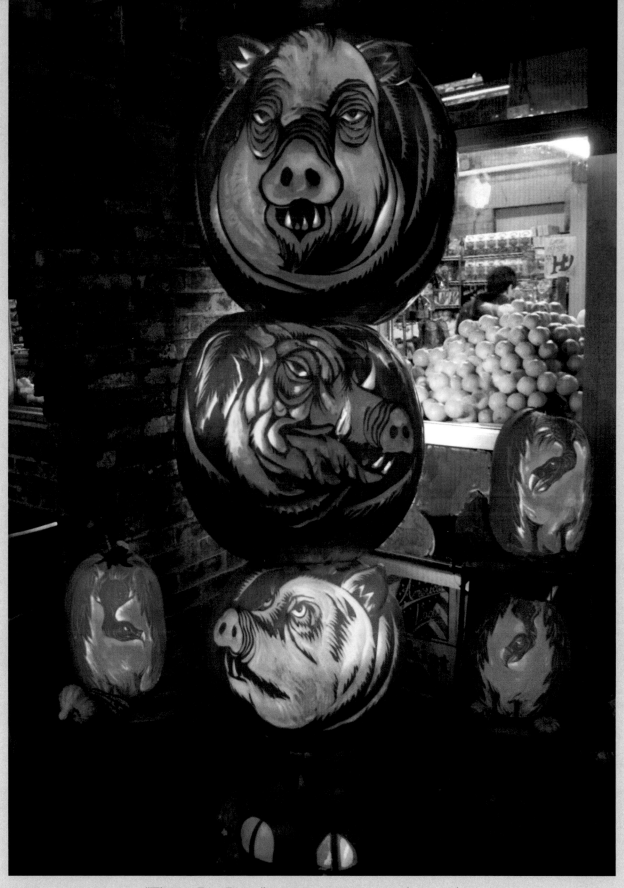

"Three Big Pigs," 125 to 200-pound pumpkins

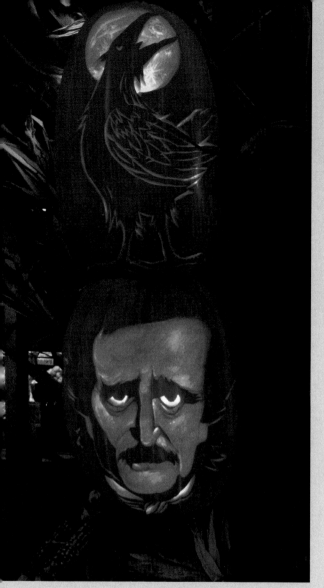

"Edgar Allan Poe" with raven

"The Chicken or the Egg?"

Birds of

a

Feather

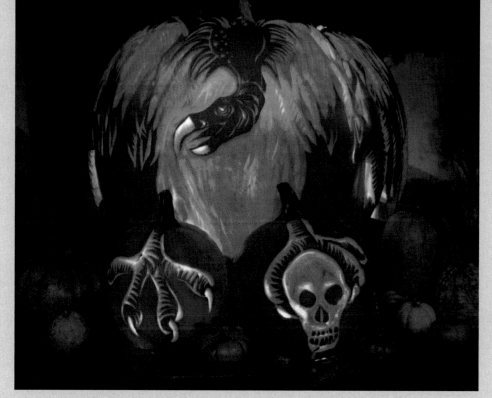

"Vulture," 600-pound pumpkin, Chelsea Market

"Alfred Hitchcock," 300-pound pumpkin

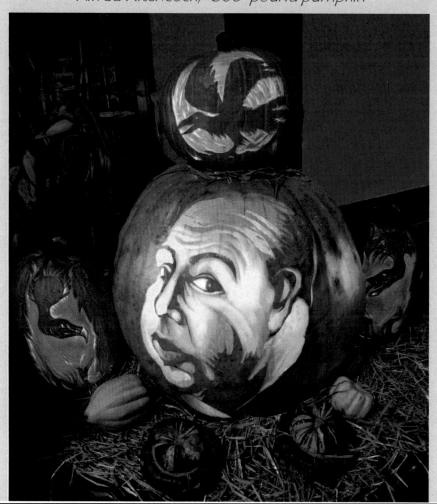

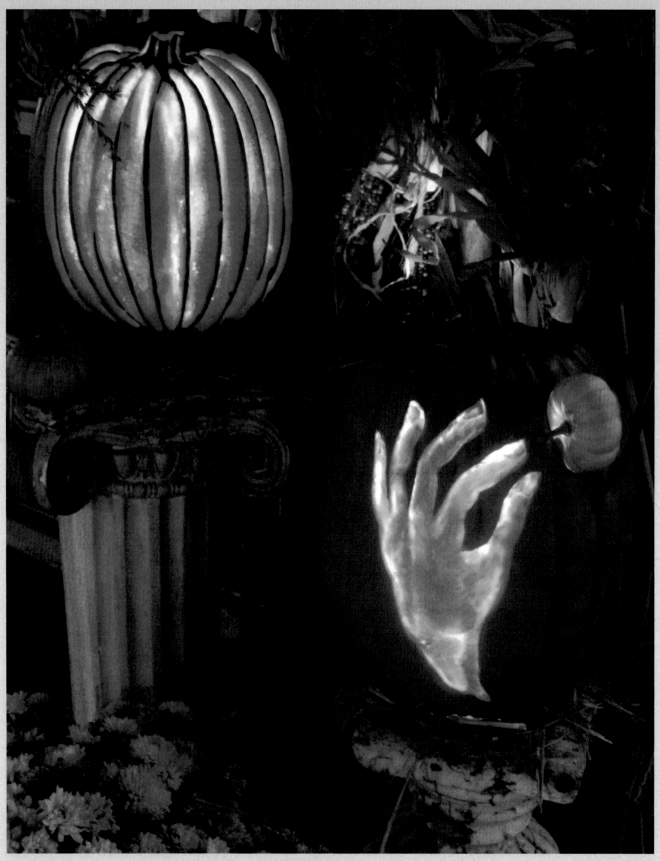

Chelsea Market

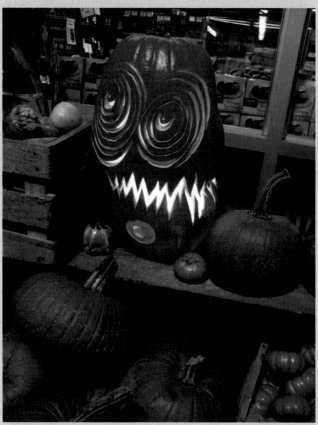

Chelsea Market

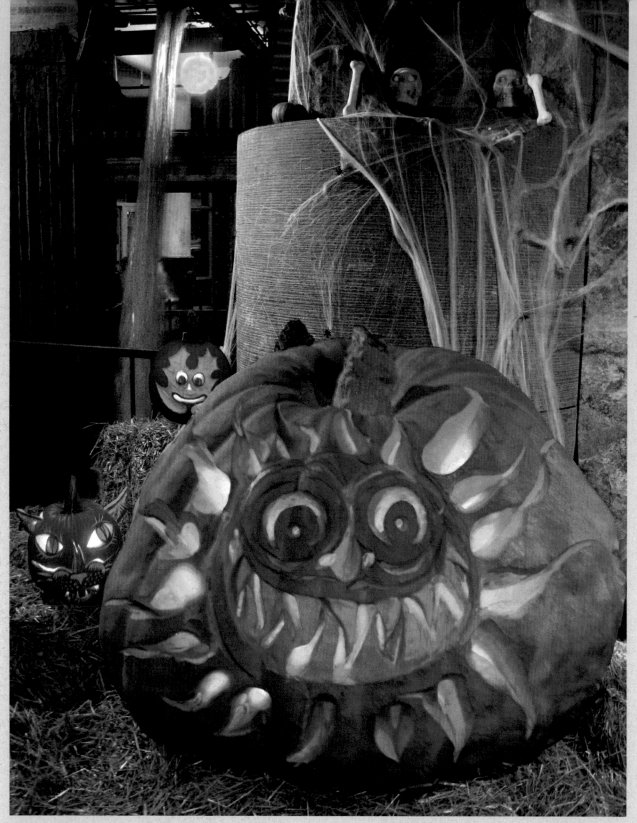

"Scary Sun!" In 2007 it was an unusually hot fall season. The pumpkins were melting, inspiring my testimony to Global Warming in a 1,662-pound pumpkin carving.

Mr. Met, Scary New York Mets Mascot, 300-pound pumpkin

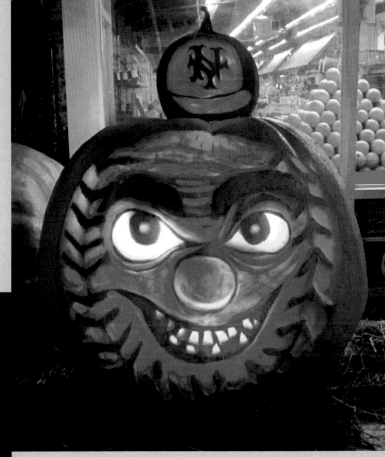

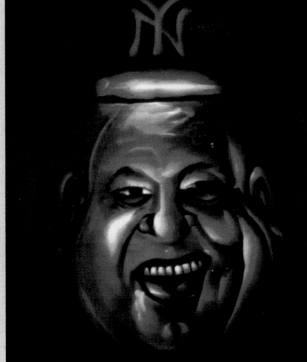

Don Zimmer, New York Yankees manager

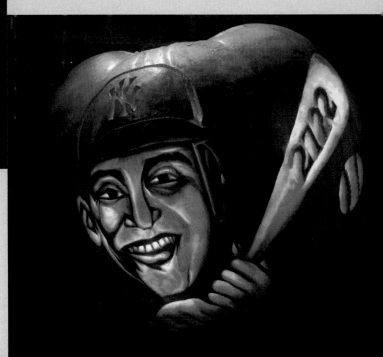

Derek Jeter, New York Yankees,

2722 hits

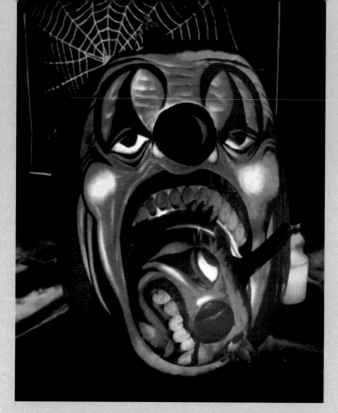

It's a Clown-Eat-Clown World

When the Food Network hired me to carve this TV promotion, they initially wanted a haunted house. I convince them to do an eating theme. The clown's teeth are pumpkin seeds! Food Network also sponsored me to carve for New York City Food and Wine Festival several times.

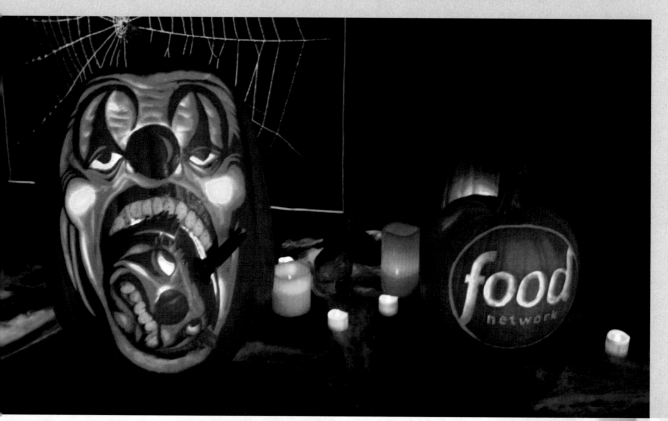

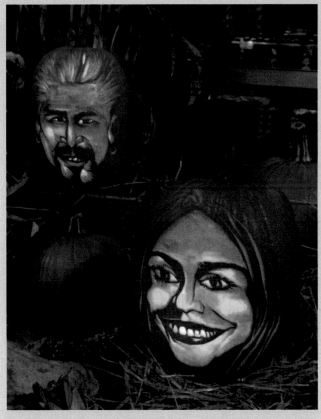

Guy Fieri and Rachel Ray

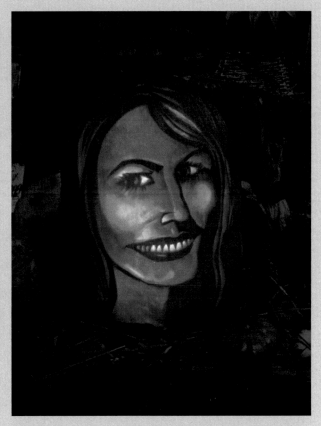

Sandra Lee

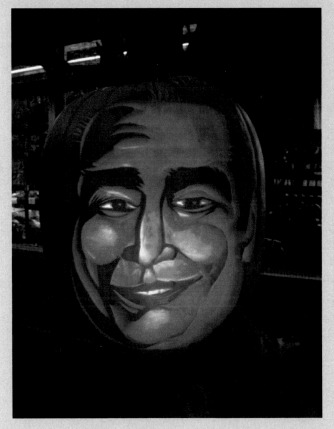

Emeril Lagasse- BAM!

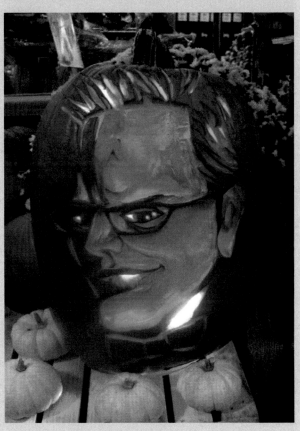

Alton Brown

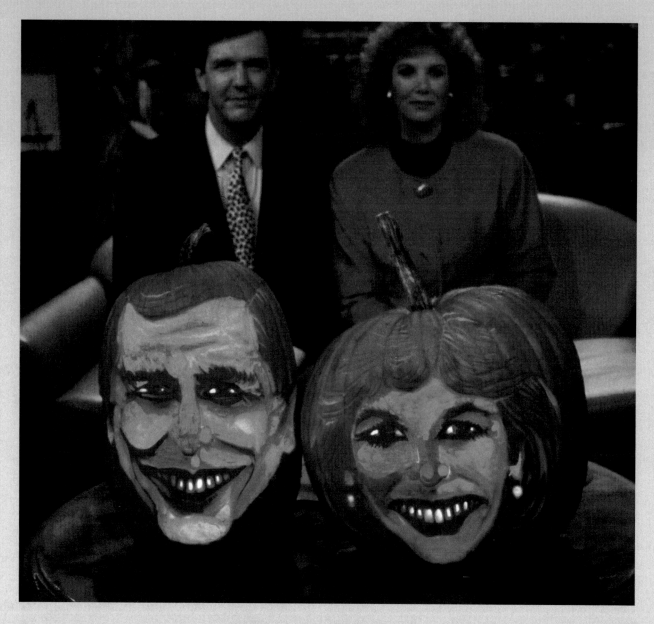

More Television

In 1980, one of my first television portraits was of Charlie Gibson and Joan Lunden, the "co-hosts" of Good Morning America. In those days, the broadcasting companies would pick me up in a stretch limousine along with my pumpkins. The David Letterman and Conan O'Brien programs hired me to carve portraits live on air; cutting to my carving progress throughout the programs.

For the Colbert Report, Steven Colbert used an image of my Obama and McCain portraits. When he did a comedy skit with a Ready Whip canister, the PR company for Ready Whip hired me to carve a watermelon portrait of Colbert as a thank you gift.

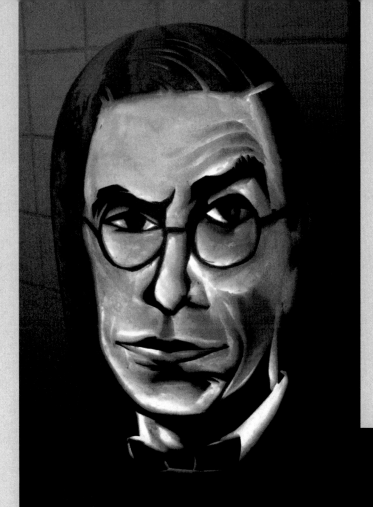

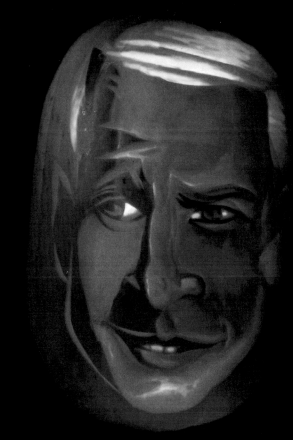

Steven Colbert

A portrait carving for Anderson Cooper's daytime talk show, "Anderson."

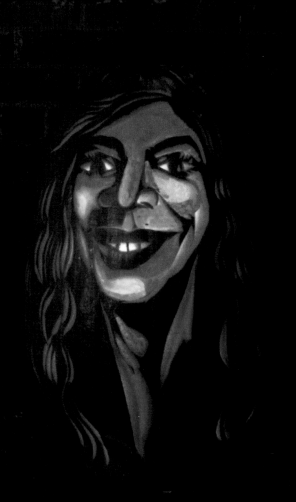

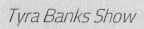

Tyra Banks Show

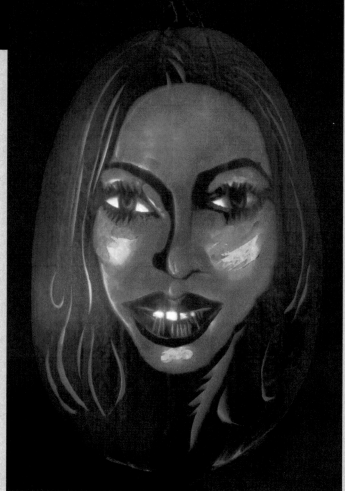

Lady Gaga

Einstein
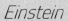

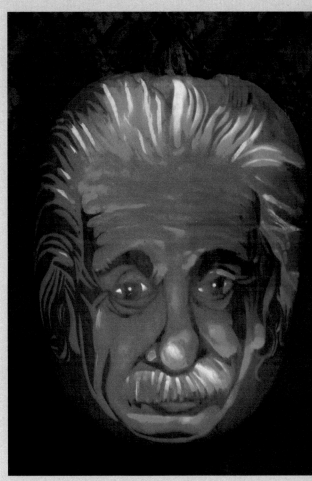

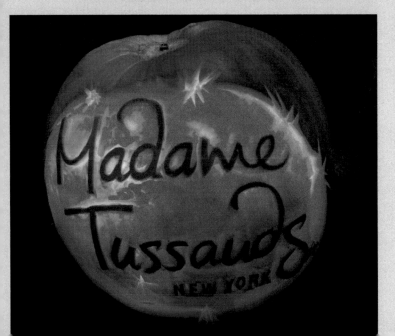

A Madame Tussauds Wax Museum promotion, New York City.

73

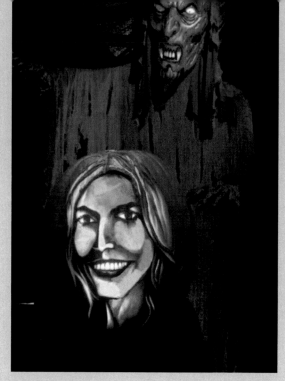

Hedi Klum

Ladies of the Halloween

In 1997, models Naomi Campbell and Kate Moss hosted one of the first celebrity Halloween parties at the Supper Club in New York City; I carved pumpkins for the event. Hedi Klum was a guest, and the evening inspired her annual Halloween and costume extravaganzas which I carved for many times.

Later, I carved pumpkins and watermelon for Bette Midler's Hawaiian themed "Hullaween," a fundraiser for her New York Restoration Project. Mariah Carey hired me to carve butterflies based on her recent album. Nick Cannon, her husband, was the DJ for her Halloween party. I also carve a 150-pound pumpkin for Kim Kardashian's Party at LAVO.

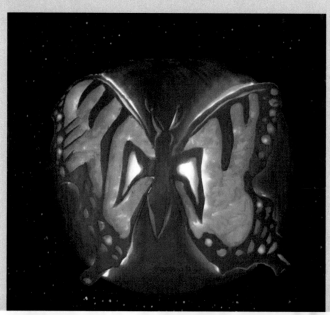

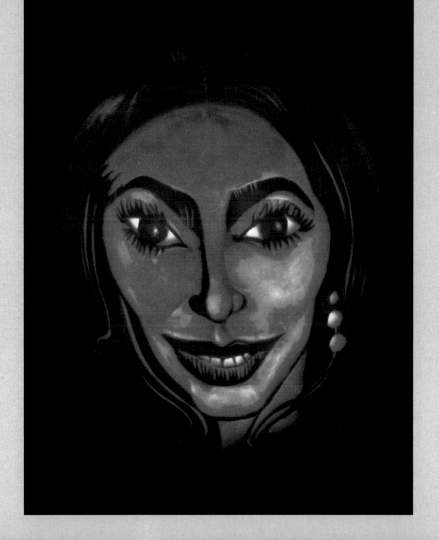

Kim Kardashian

Bette Midler

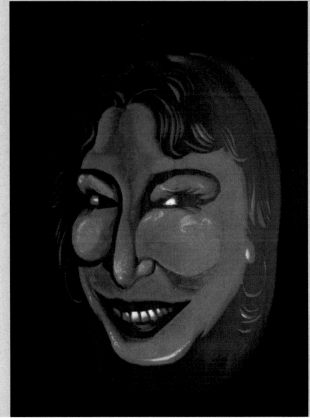

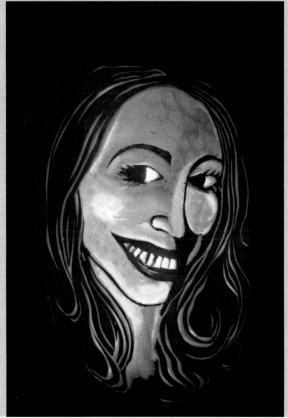

Mariah Carey

Eloise and Company

The folks at the Plaza Hotel put me in a Pumpkin King costume to present my carved portrait of Eloise to an enthusiastic audience of young pumpkin carvers. Kay Thompson's 1950's children's book character, Eloise, along with her dog, Weenie, and turtle, Skipperdee are mischievous fictional residents of the hotel, who are to this day endearing Plaza Mascots.

I've conducted many participatory carving sessions with demonstration and instruction for adults and children for many corporate clients including Viacom, Facebook, IBM, McKinley Financial Services Silo Ridge Field Club, IBM, and Central Park Conservancy.

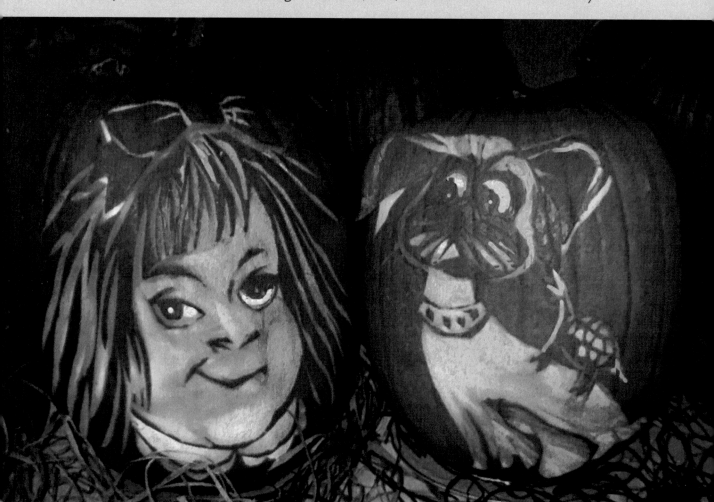

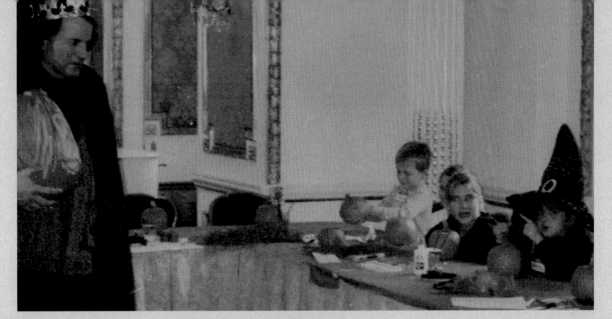

The Plaza Hotel

Green Thumbs, Harlem, NYC

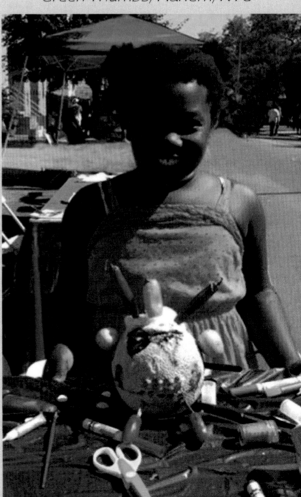

Silo Ridge Field Club

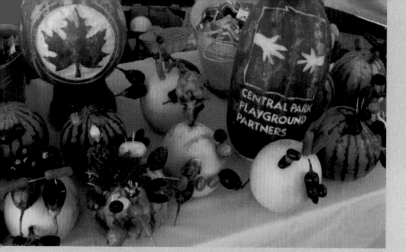

Green Thumbs, Harlem, NYC

Private party, Connecticut

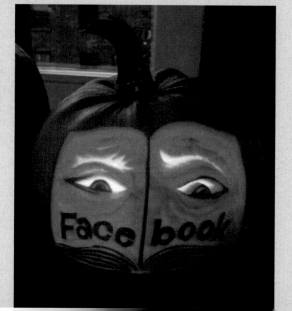

Facebook Corporate party

Viacom (MTV and Nickelodeon) corporate pumpkin carving party

Sponge Bob

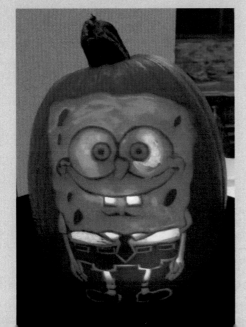

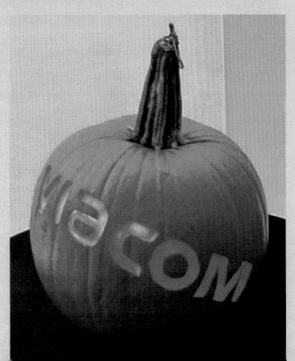

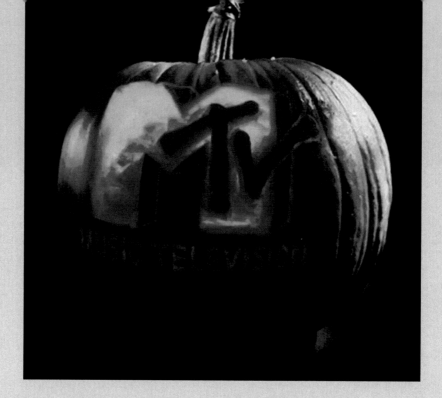

The Logo

A pumpkin logo carving is a useful calling card to help get my foot in the door at media companies, corporations, restaurants, and major events throughout the United States.

I was the first one to carve the MTV logo. I went on to carve pumpkins for Alice Cooper and Iggy Pop's Headbangers MTV program. Iggy showed up with a bucket of peanut butter that he smeared on his face, scaring the kids.

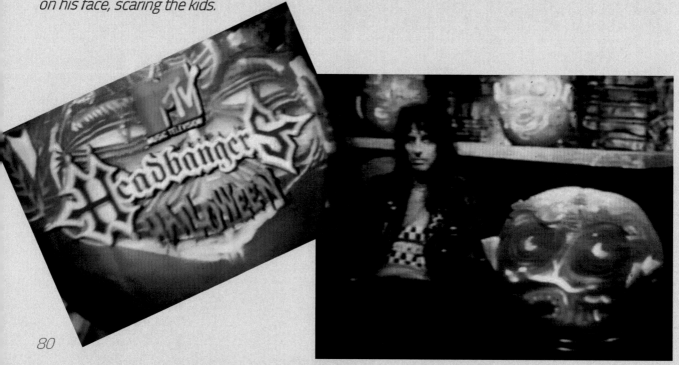

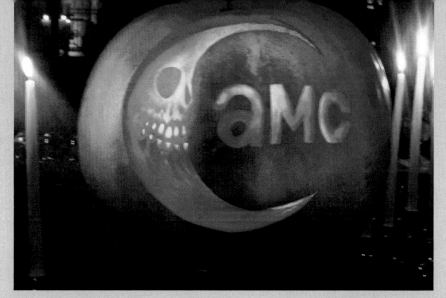

AMC, Walking Dead party, New York City

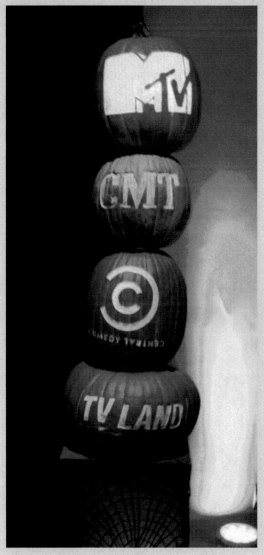

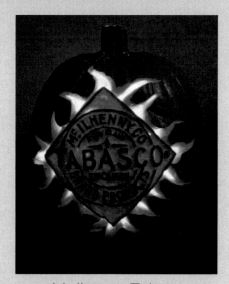

McIhenny Tabasco,
Avery Island, Louisiana

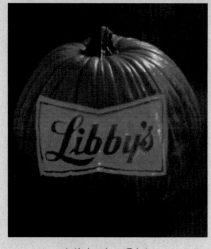

Viacom party, New York City

Libby's, Ohio

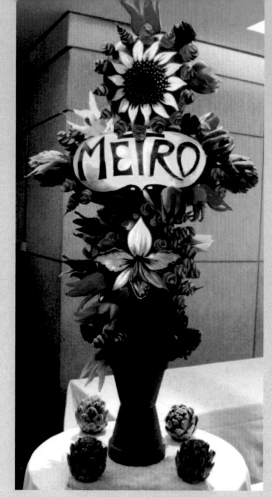

"Crème de la Crème," City Meals on Wheels, tribute to French chefs, New York City

Edible Manhattan event

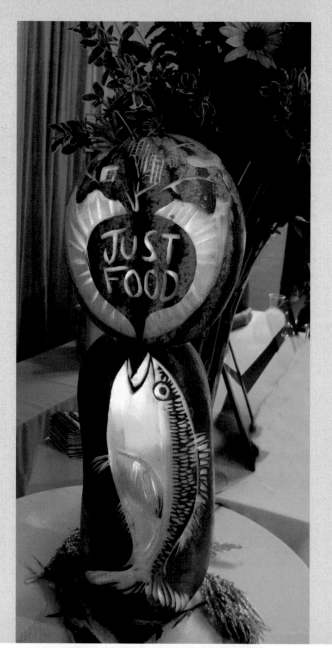

Brooklyn's Borough President, Marty Markowitz's, retirement party was at Noodle Pudding in Brooklyn, New York. A few years earlier, Marty proclaimed October 28, 2008, "Hugh McMahon Celebration Day."

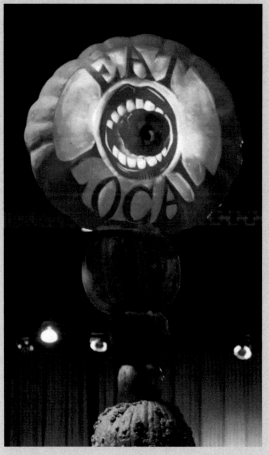

Brooklyn Uncorked Just Food 83

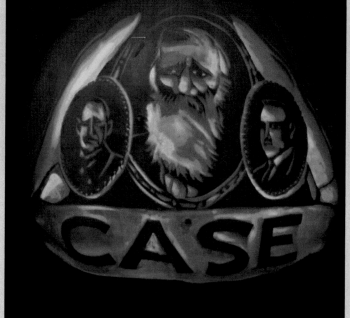

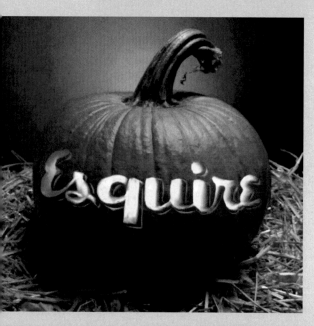

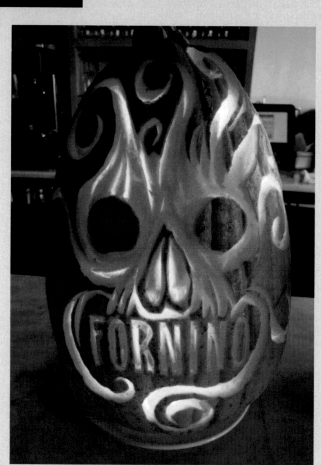

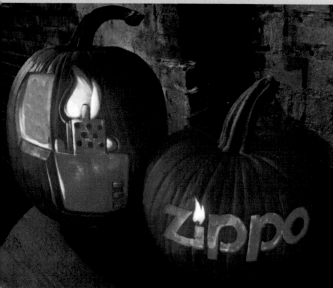

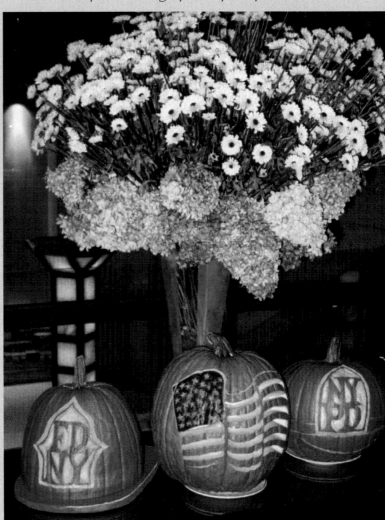

Starbucks sponsored me on Good Morning America, promoting spiced pumpkin lattes.

Farm Aid

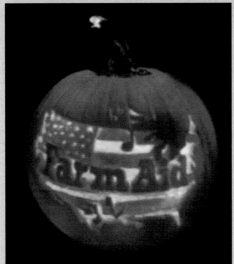

Grateful Dead

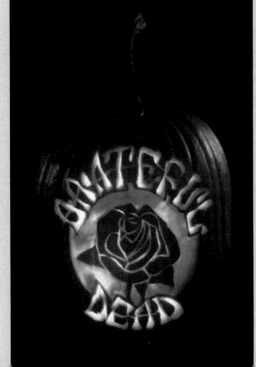

9/11 Tribute, Four Season Hotel, New York

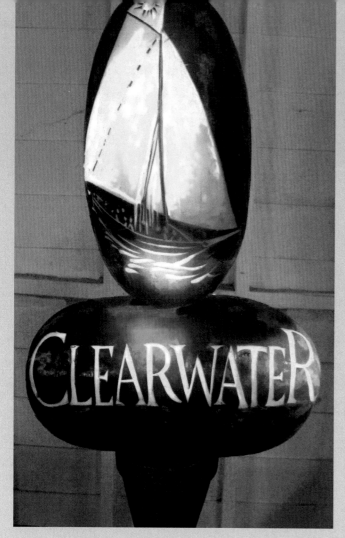

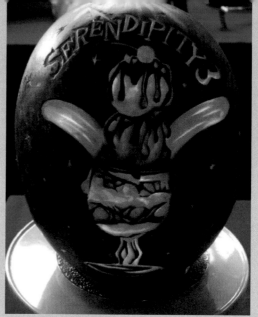

Serendipity 3

Clearwater Music Festival

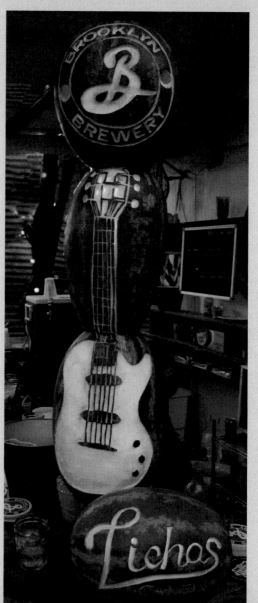

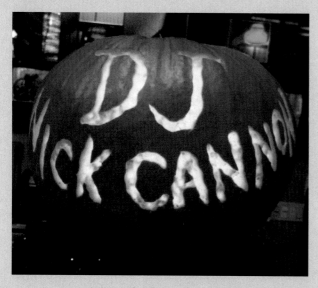

Mariah Carry's party

Moxy Hotel, A green pumpkin

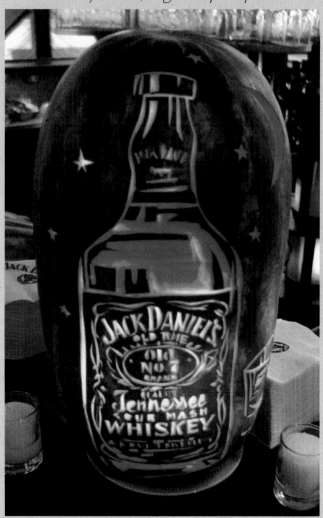

Tribute to Jack Daniels, Four Seasons Restaurant

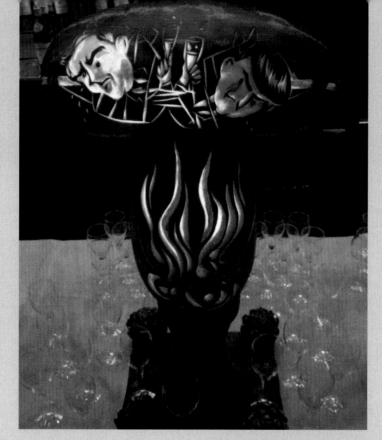

Four Seasons

Julian Niccolini and Alex Von Bidder subjected themselves to a comic roasting by New York celebrities and other customers. Ultimately, I depicted them barbequed, as shown in the comic caricatures on the invitations.

For Halloween, I carved "Masks of the World" in candlelit pumpkins, enhancing Architect, Philip Johnson's design for the pool room.

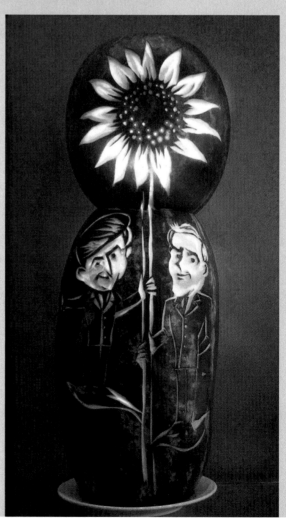

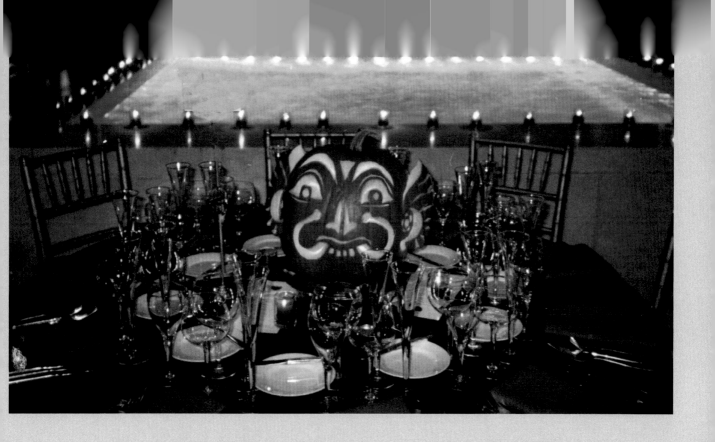

Masks of the World, Four Seasons Restaurant, New York City

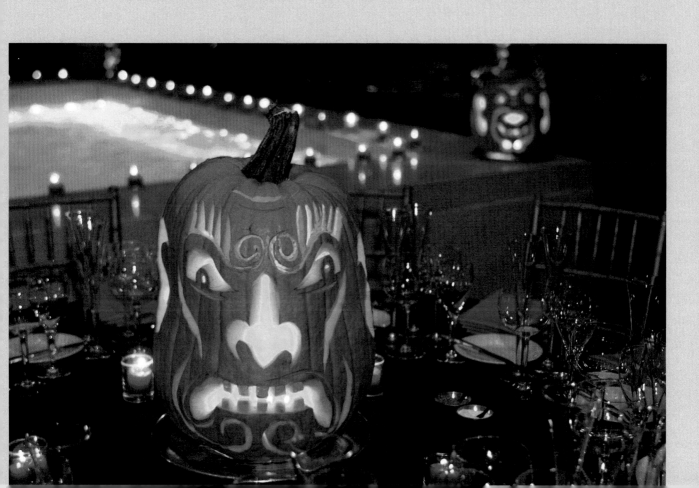

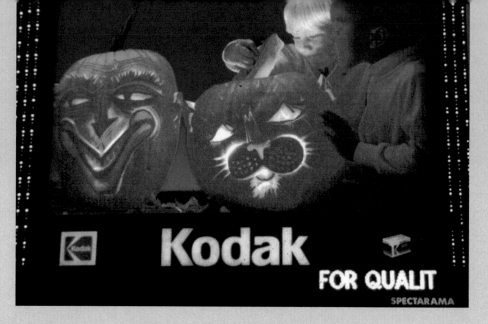

Published Pumpkins

Kodak invited me up to Rochester NY to carve for a photo mural that was bill-boarded at Grand Central Station in New York City. Then the photo made its way to Time Square.

Mad Magazines editors, Nick Meglin and John Ficarra, were at first apprehensive about my carving of Alfred E Newman. They thought the portrait was over-carved. "Not pumpkin'ish enough," but they eventually went with it.

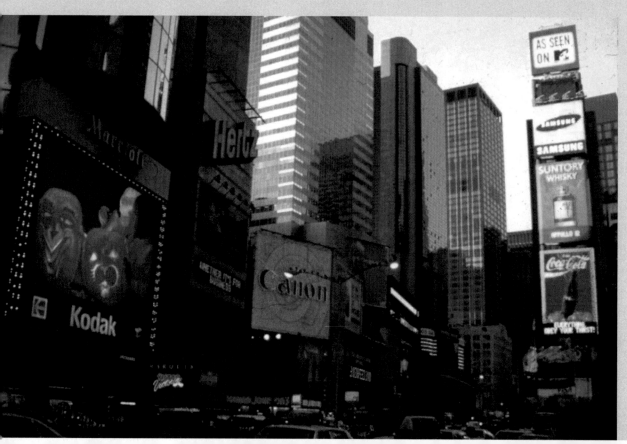

Kodak Photo Mural Time Square, NYC

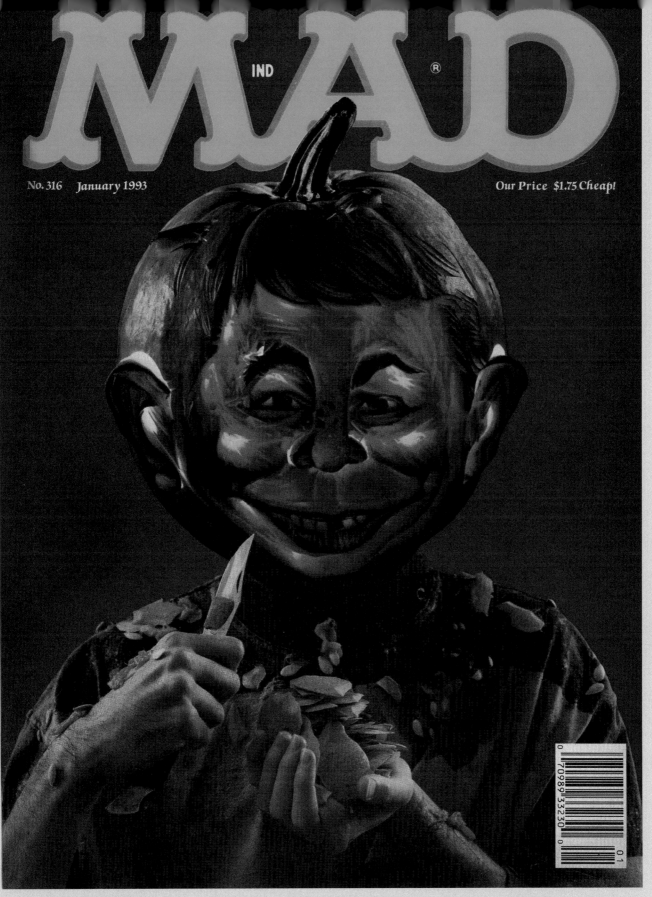

Mad Magazine cover, MAD 316 © E.C Publishing Inc: Photo by Irving Schild

Dial Publishing's Children's Book, "Night of the Pumpkinheads."

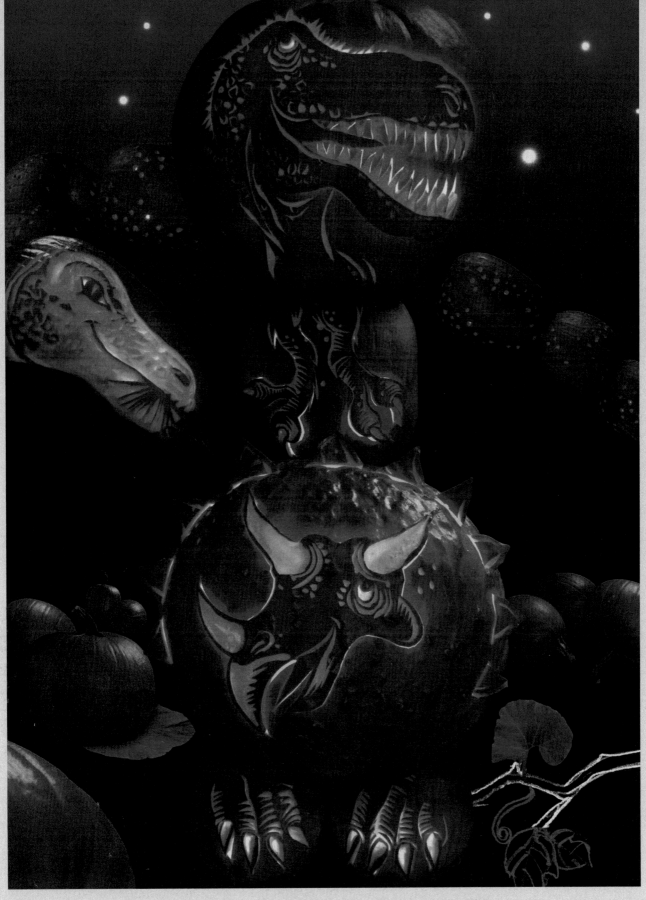

Photos by William Brinson, authored by Michael Rosen

93

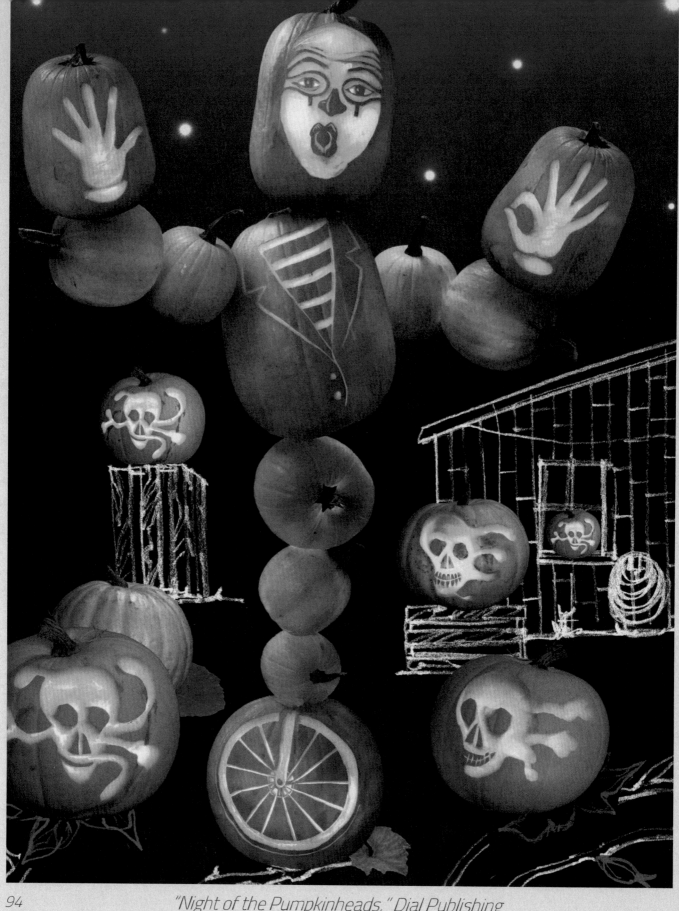

"Night of the Pumpkinheads," Dial Publishing

Guinness World Records

FLIP THE MAGAZINE OVER TO PAGE 6 TO HELP SET A GUINNESS WORLD RECORD!

WORLD'S HEAVIEST PUMPKIN!

AS PART OF A FUND-RAISING EVENT AT NEW YORK CITY'S GRAND CENTRAL STATION, ARTIST HUGH MCMAHON CARVED THE RECORD-SETTING PUMPKIN INTO THE FACE OF A GORILLA.

What would *you* look like if you gained 40 pounds a day for three weeks? That's just what happened to the world's heaviest pumpkin during its peak growth. In fact, the pumpkin was still growing three pounds a day when Ron Wallace of Greene, Rhode Island, finally cut the monster gourd from its vine. Final weight: 1,502 pounds!

Growing a pumpkin that's more than nine feet around takes special care. Wallace said he fed his pumpkin a mixture of— *yum!*—fish, kelp, and liquid compost. Getting the pumpkin from his field to the weigh-in was no small task. "We used a special crane called a tripod to lift it onto a trailer," Wallace says. "It was too big for a truck bed."

Wallace turned down offers of $10,000 for the pumpkin. He eventually sold it at a much lower price so the pumpkin could be used at a fund-raising event for the Food Bank For New York City. But it wasn't just the pumpkin that was worth something. "The seeds themselves sold for between $200 and $450," Wallace says. He had to work for the seeds, though: Wallace dug through hundreds of pounds of guts to pick them all out!

GREAT PUMPKIN FACTS

Carver Hugh McMahon (not pictured) crawled in and out of the pumpkin for two hours to clean the guts from the pumpkin. "I got pretty sticky," he says.

The pumpkin was so thick that McMahon had to use a 200-watt lightbulb to make the pumpkin "glow," instead of the usual 60-watt bulb.

Ron Wallace grew the pumpkin (left) in 160 days. At 30 days, the pumpkin was already 600 pounds—more than a third of its final weight!

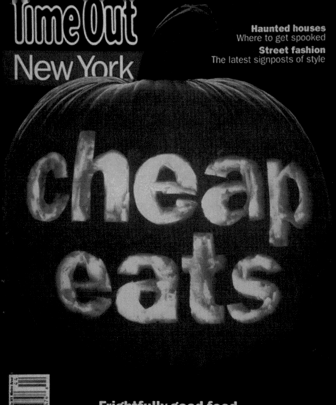

Time Out New York cover carvings

Cheap Eats!

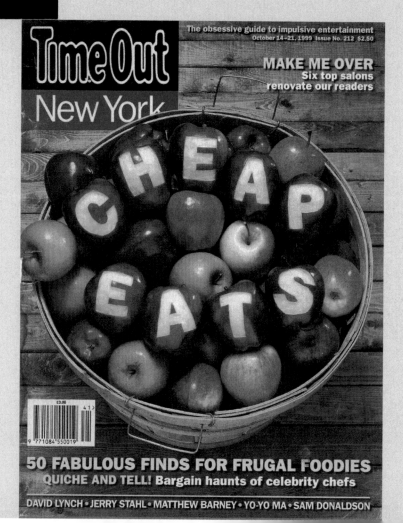

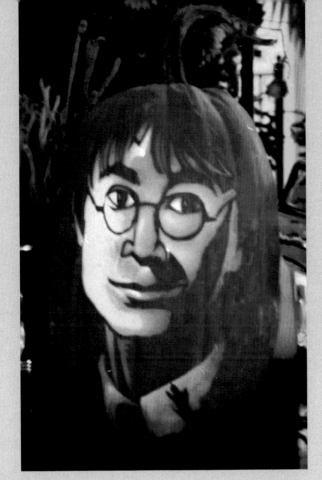

Harry Potter, carvings for an AOL
movie premiere

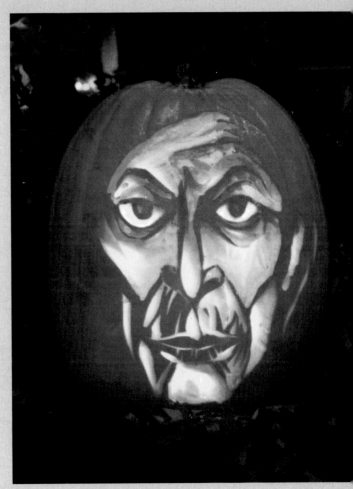

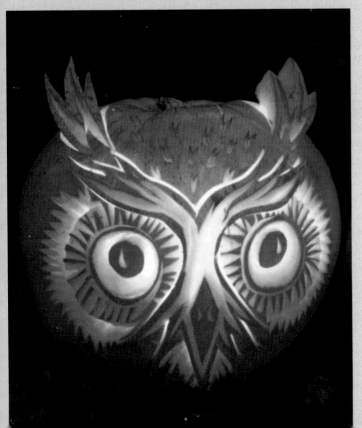

97

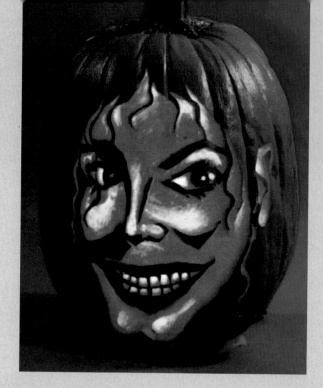

Jack-o'-Lantern

Is a carved pumpkin portrait a positive or negative? Maxim magazine ordered this Michael Jackson portrait when he was having legal problems. City Meals on Wheels wanted the below portraits of Lynda Rae Resnick, Pom Wonderful, and Martha Stewart Living celebrating their accomplishments, at the Rainbow Room. Old Navy and Elite Daily wanted celebrities that conflicted. I was happy to get the work.

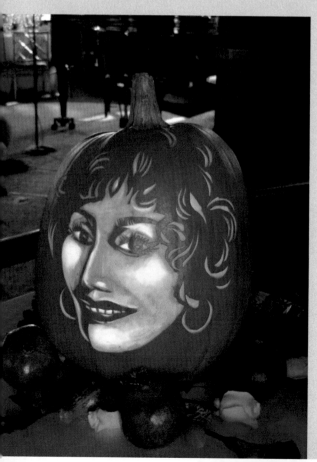

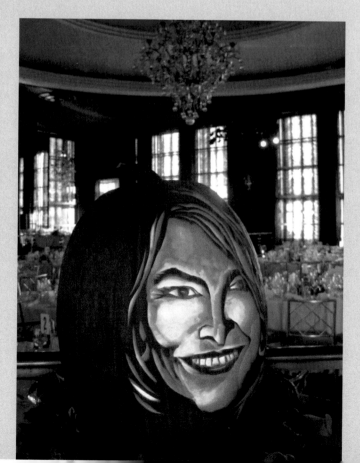

Taylor Swift and Kanye West fight
over the microphone, for Old Navy

Gerry Garcia smoking pot, for a
private party

Kim Davis who withheld
marriage licenses for gay
men, for Elite Daily

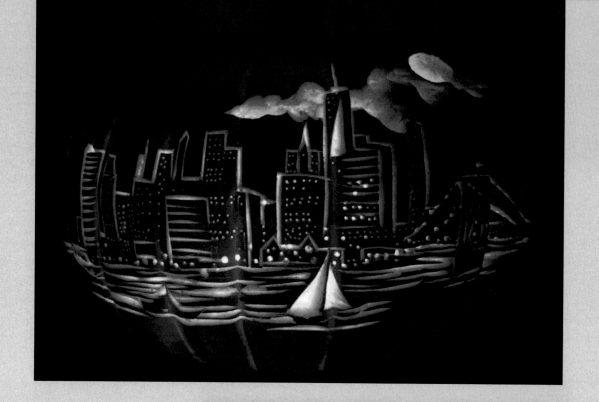

New Yorkers

W Hotel in New York City, celebrating New York and its celebrities with carvings in its Union Square windows.

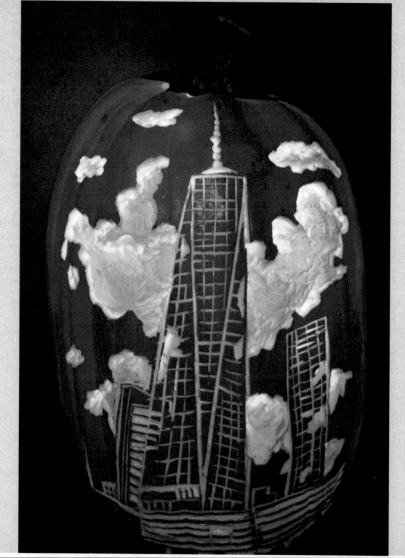

Freedom Towers

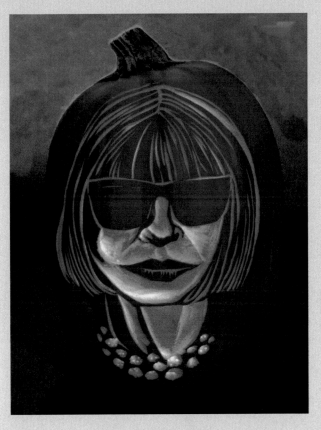

Anna Wintour

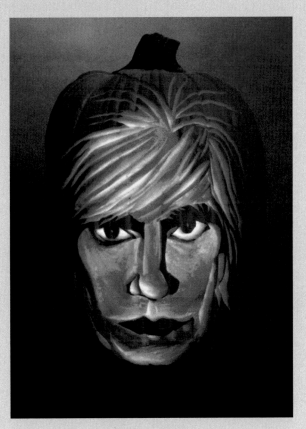

Andy Warhol

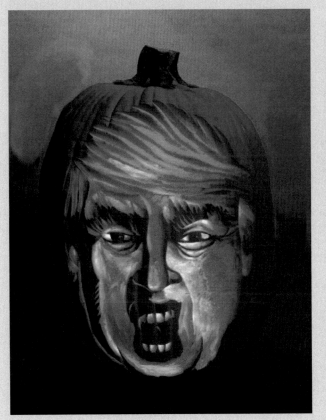

Donald Trump

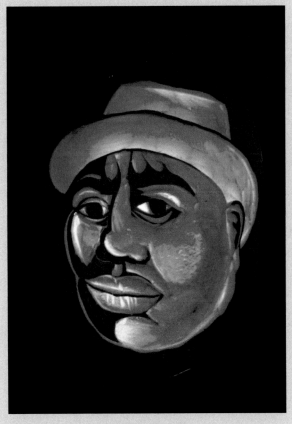

Biggie Smalls

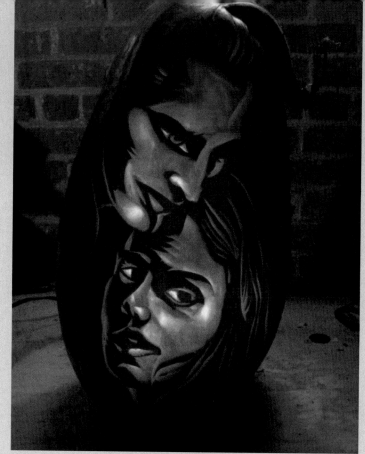

Twilight

Phantom of the Opera, an Internet promotion

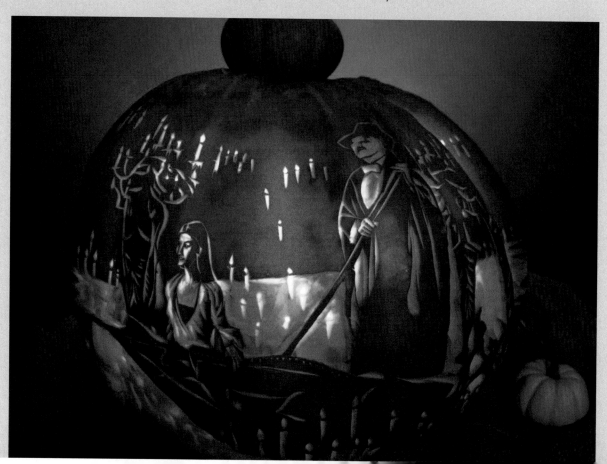

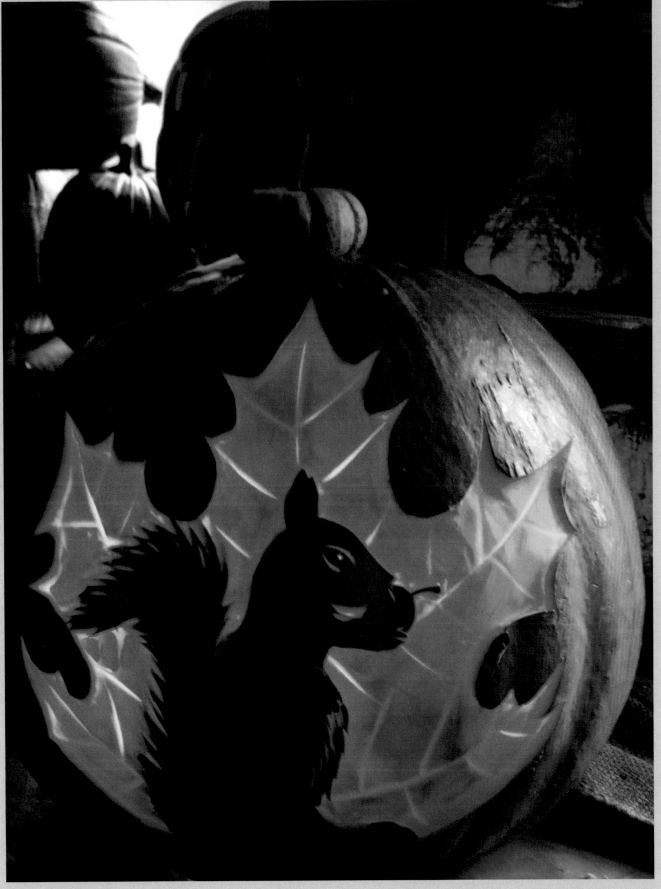

Thanksgiving

The Beast

My experience has been that the artistically inclined, in their youth, started out by drawing animals. For those many, what remains is a love of creatures, real and imaginary.

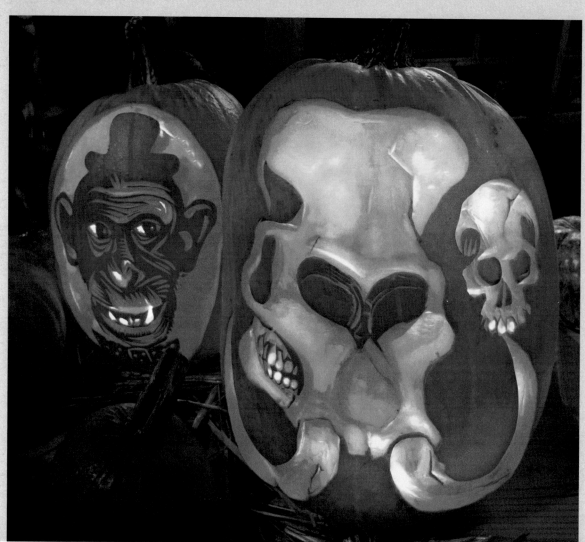

Hedi Klum's party and Chelsea Market

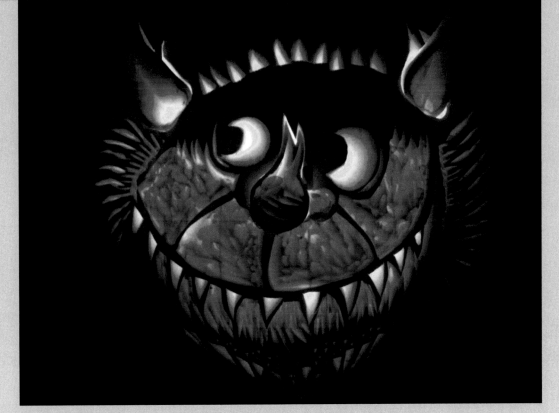

Influenced by Maurice Sendak's

"Where the Wild Things Are."

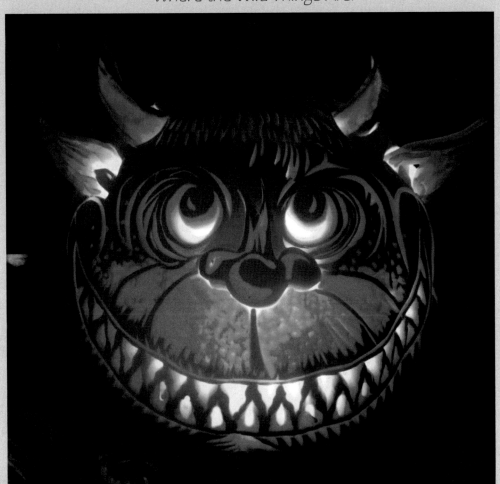

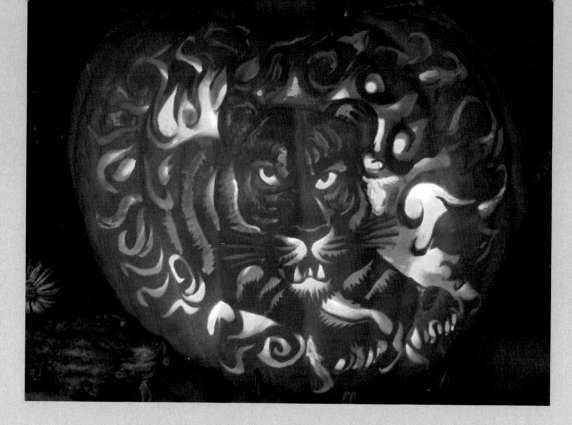

Wheatly Plaza Tiger, 600-pound pumpkin

TAO Tiger

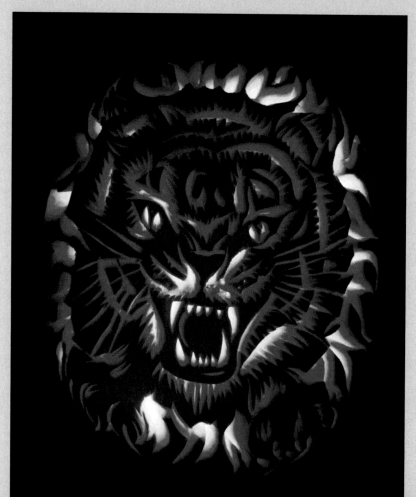

106

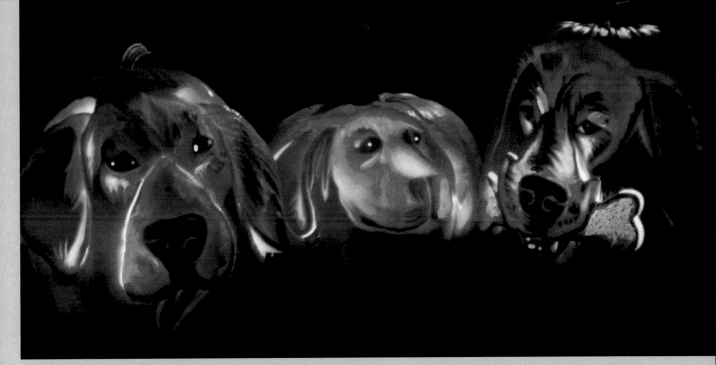

Thanksgiving carving for Marlo Thomas and Phil Donahue; a portrait of their three beloved dogs

"Bull and Bear," carving for a Goldman Sachs Wall Street luncheon

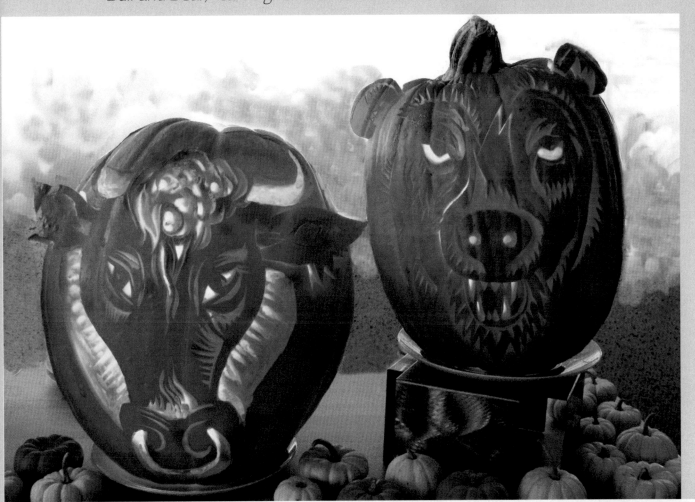

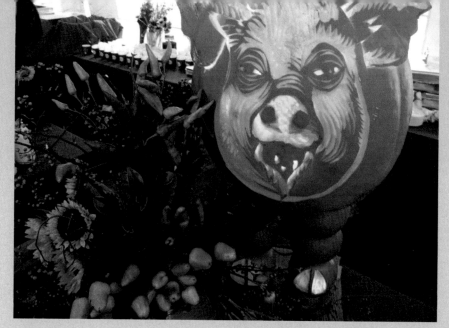

Duke's Restaurant

"Three Little Pigs"

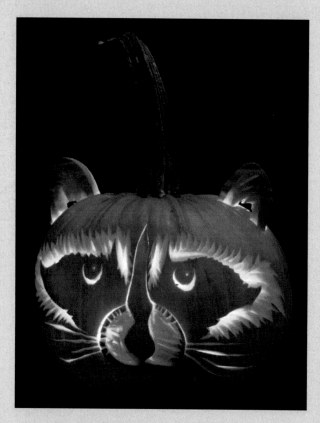

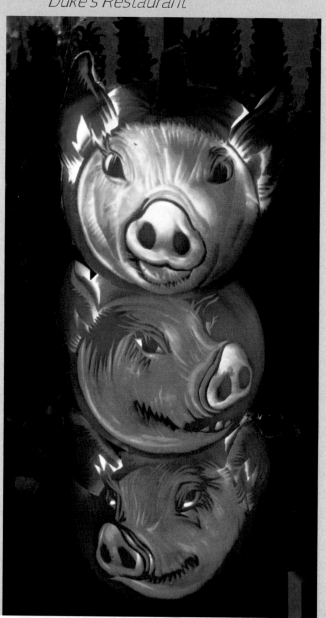

Racoon, Chelsea Market

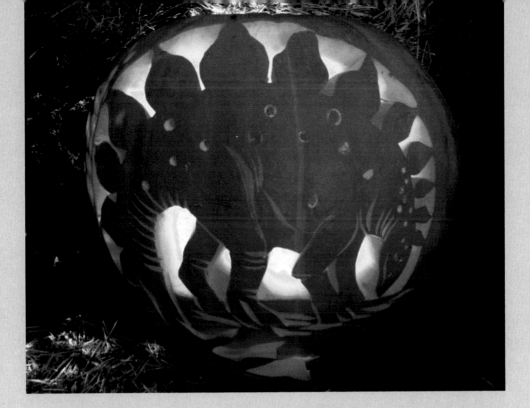

Wheatly Plaza, Stegosaurus and "Balancing Act" Elephant

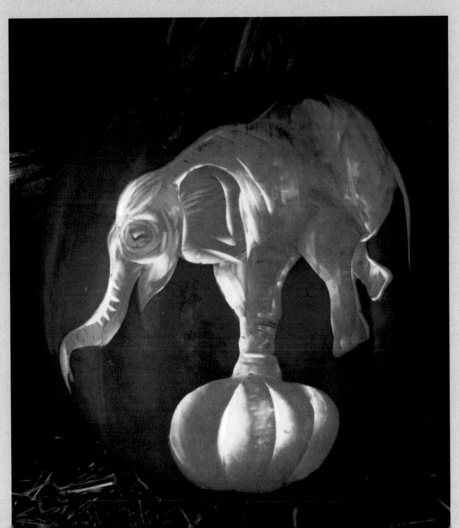

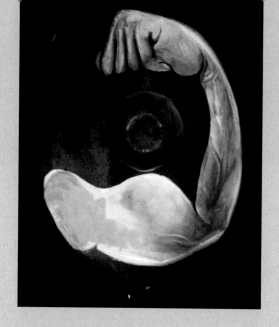

Contenders

City Meals on Wheels had a benefit at the Rockefeller Center, New York City, "Rumble at the Rock" pitting east coast chefs against west coast chefs. I used the orange (west) and apple (east) to define the conflict in watermelons.

The choreographer, Susan Marshall, opened a dance production at Brooklyn Academy of Music (BAM) dramatizing the conflicts between men and women. She titled it, "Contenders."

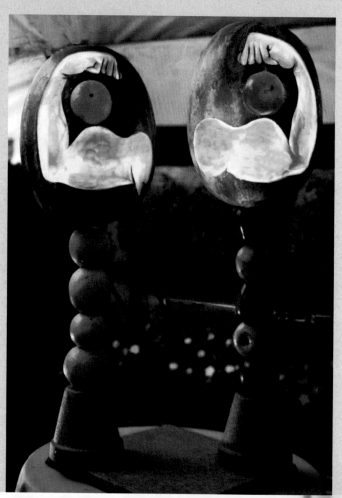

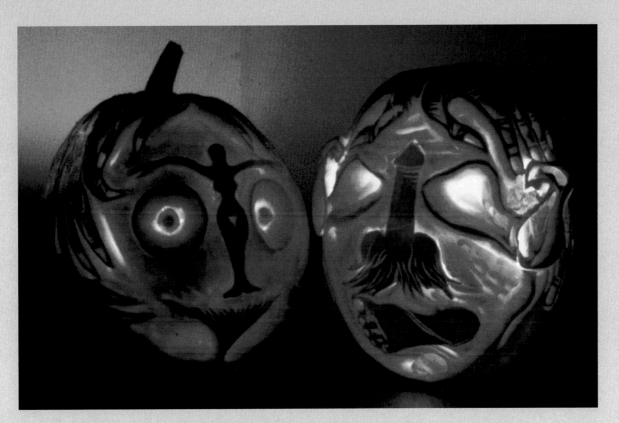

Susan Marshall's "Contenders"

Egyptian Goddess Isis, Gia Restaurant

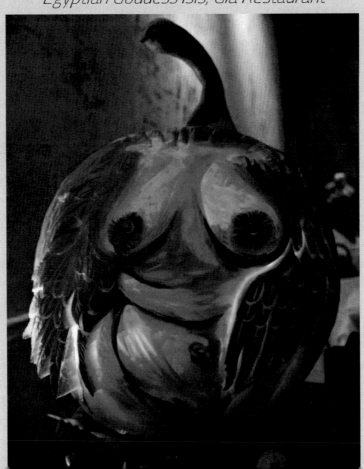

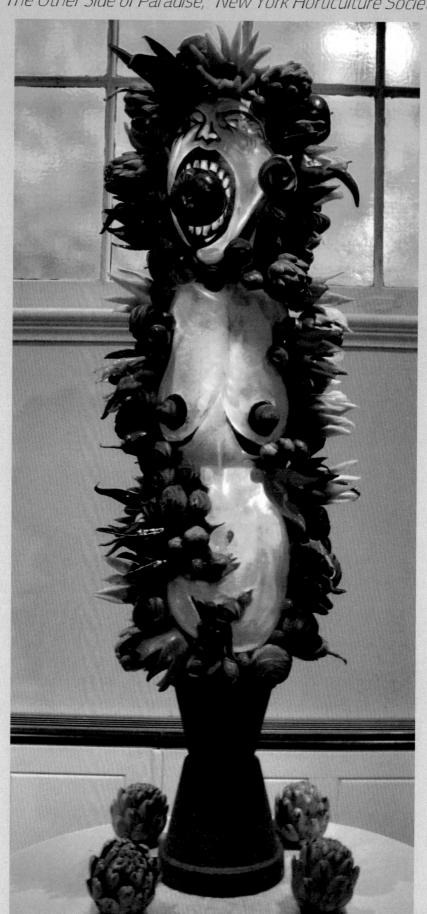

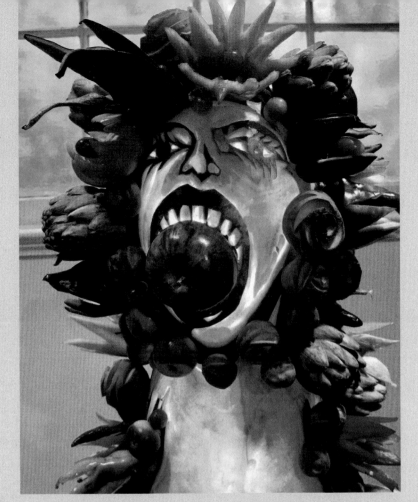

"Eve." New York Horticultural Society

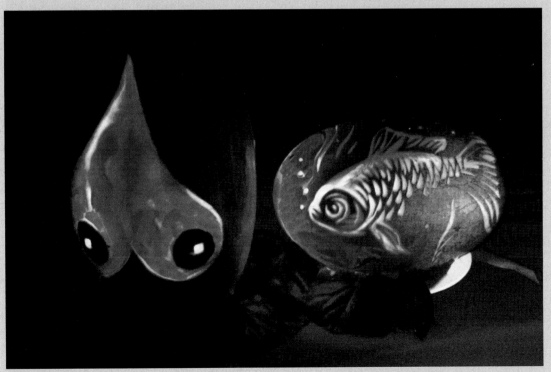

Hedonism 3, Jamaica

World Financial Center carving demonstration in the Winter Garden

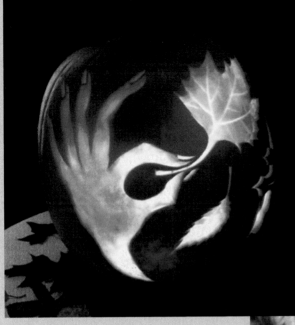

Witching Hour

Time is always an issue for the pumpkin and melon carver. A fresh cut pumpkin rot in four to six days, a watermelon rots in three to four days. I spray them with lemon juice and try never to be too far from a refrigerator.

For pumpkin carving, I stretch the Halloween holiday into fall harvest imagery and realize the lazy days of summer with watermelons. Time is not a friend.

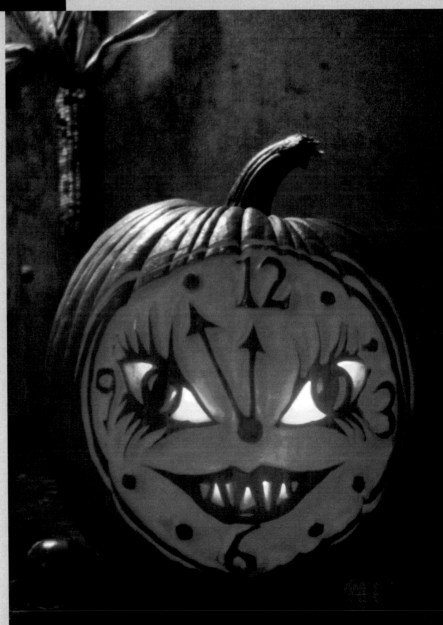

The Tower

The Tower is not only an effective way of giving a carving more presence., it visually dramatizes the ascendant.

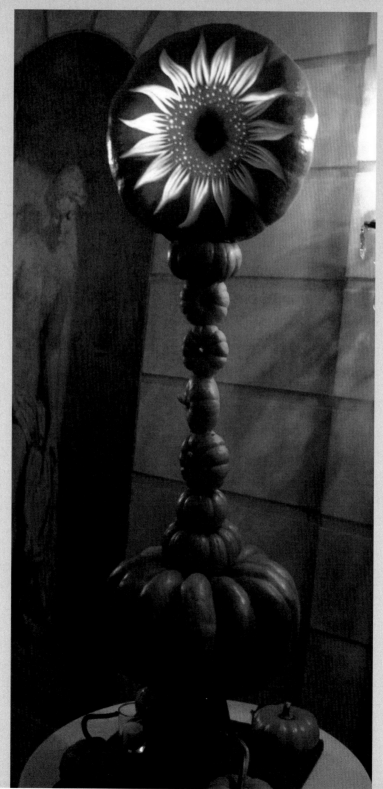

Pierre Hotel

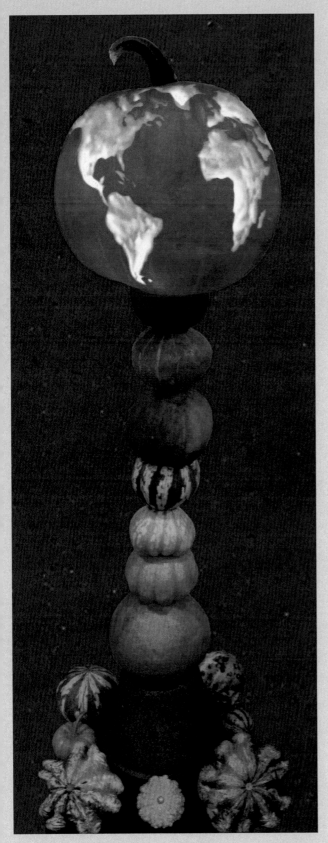

"The Globe," Salon de
Culinary Arts

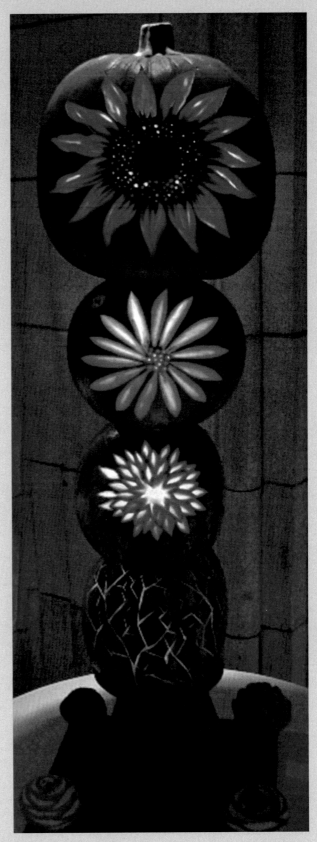

New York Horticultural Society, Four
Seasons Hotel

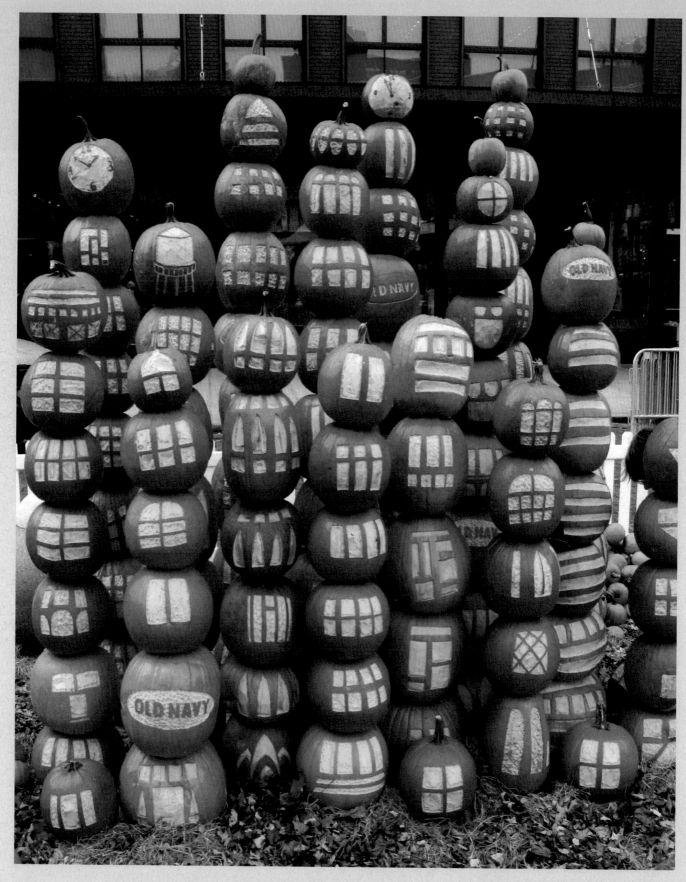

City Scape, Old Navy pop-up pumpkin patch

An American Place Restaurant

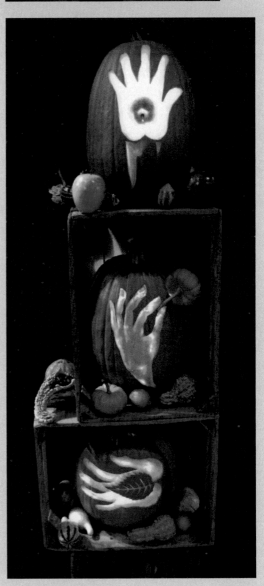

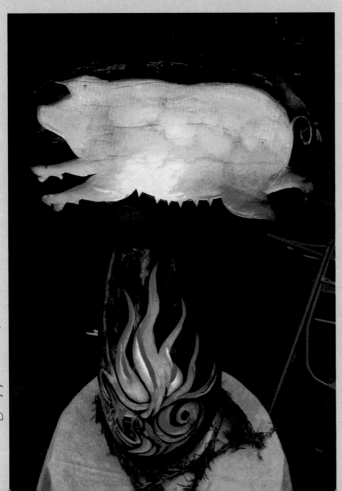

Big Apple BBQ Festival

Chelsea Market

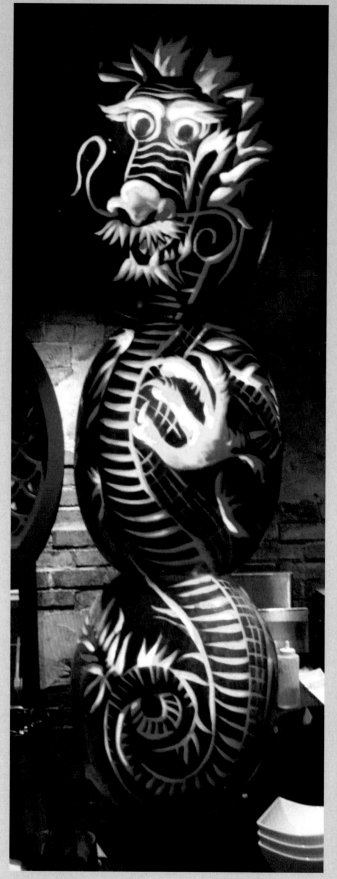

Chinese New Year, TAO

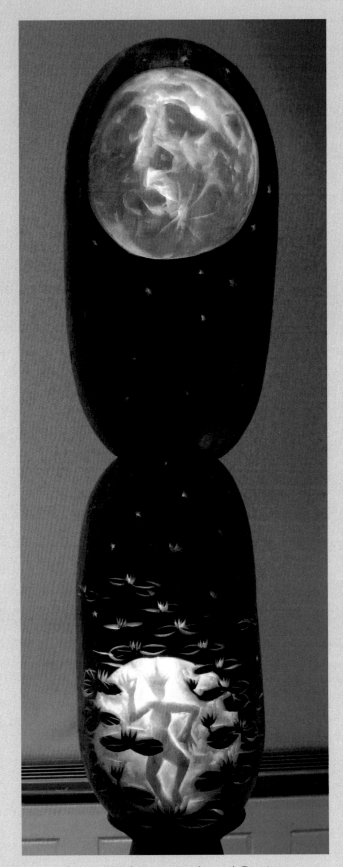

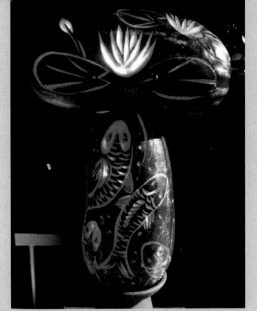

American Museum of
Natural History

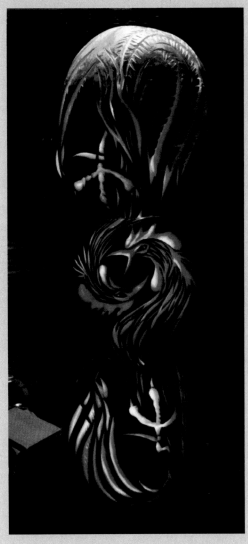

New York Horticultural Society

Year of the Rooster, TAO

121

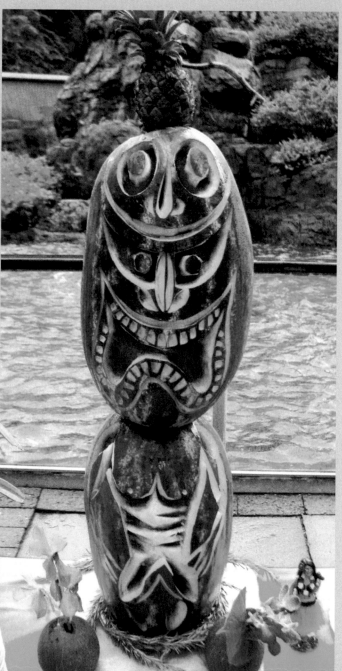

"Tutto Italia," City Meals on Wheels, New York City

Hawaiian Party, Central Park Zoo, New York City

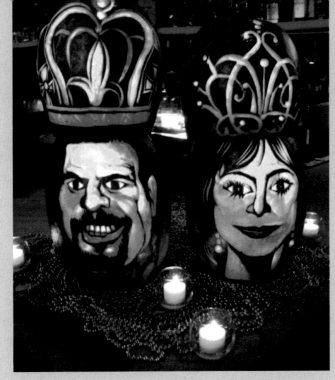

Mardi Gras, King and Queens, actors Luis Guzman and Susan Sarandon, New York City

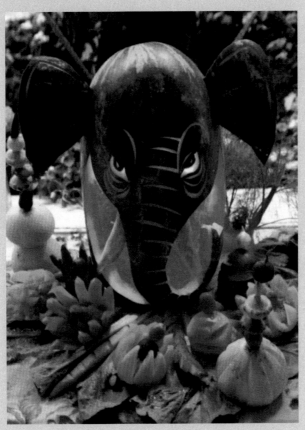

Indian wedding, Tavern on the Green, New York City

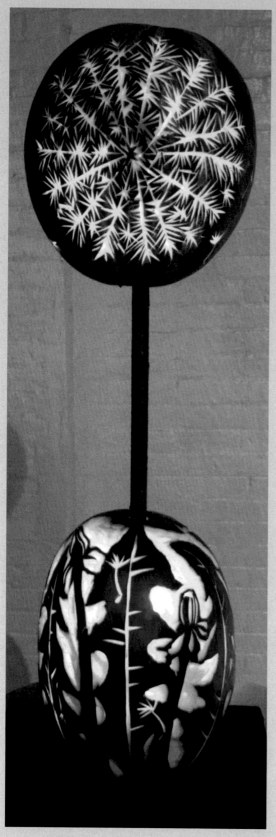

"Dandelion," New York
Horticultural Society

124

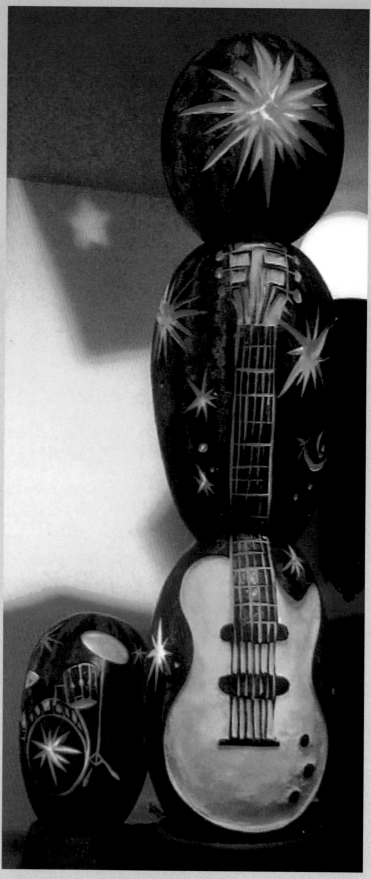

Kids for Kids

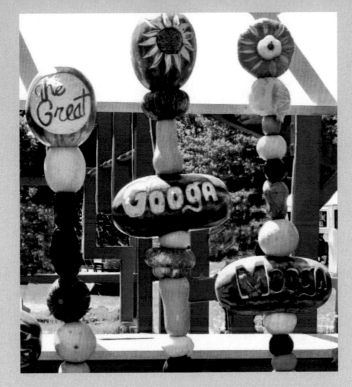

The Great Googa Mooga

It was a music and foodie festival in Brooklyn. My job was to do something with the organization Just Food in the "Urbarn."

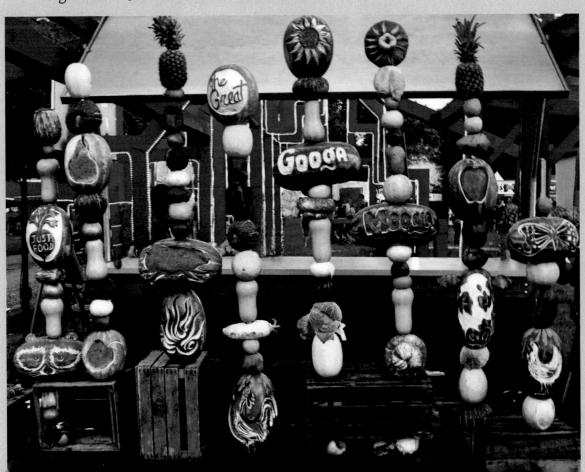

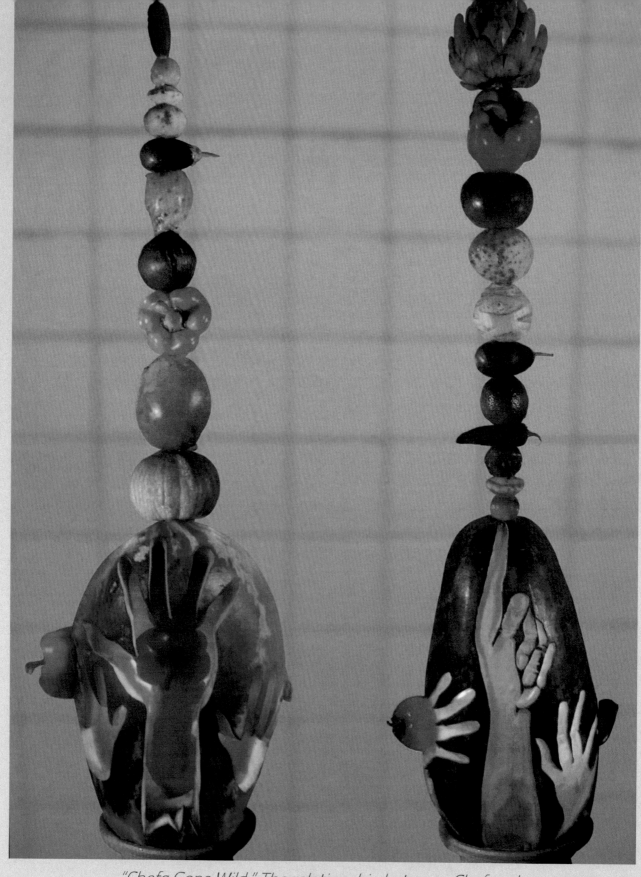

"Chefs Gone Wild," The relationship between Chef and
Farmers, City Meals on Wheels.

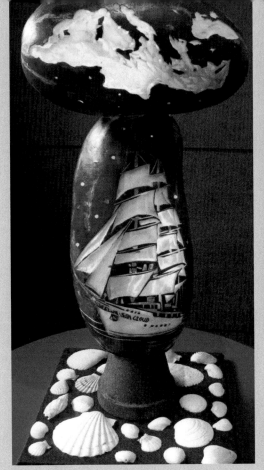

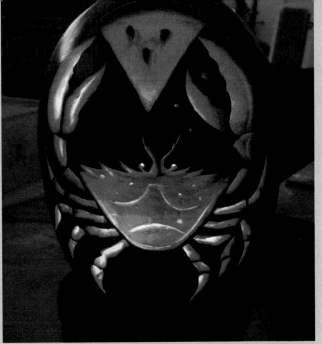

James Beard event

"White Cloud Ship," City
Meals on Wheels

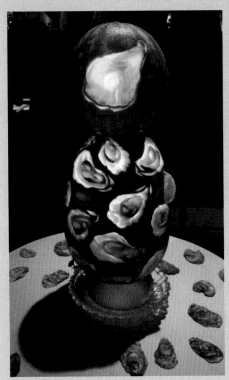

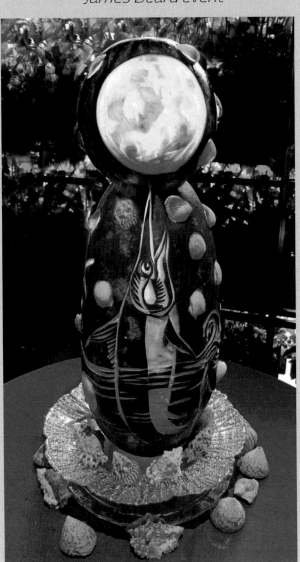

"Oysters and Pearl"

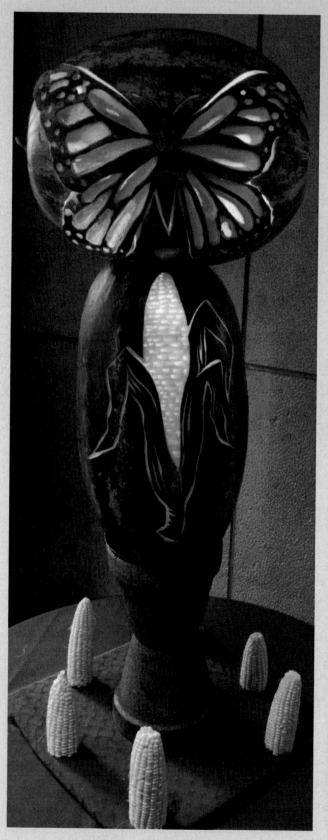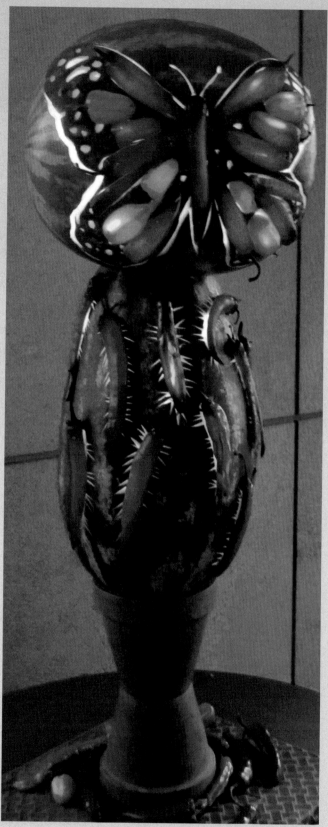

"Que Rico," a celebration of Latin cuisine, City Meals on Wheels

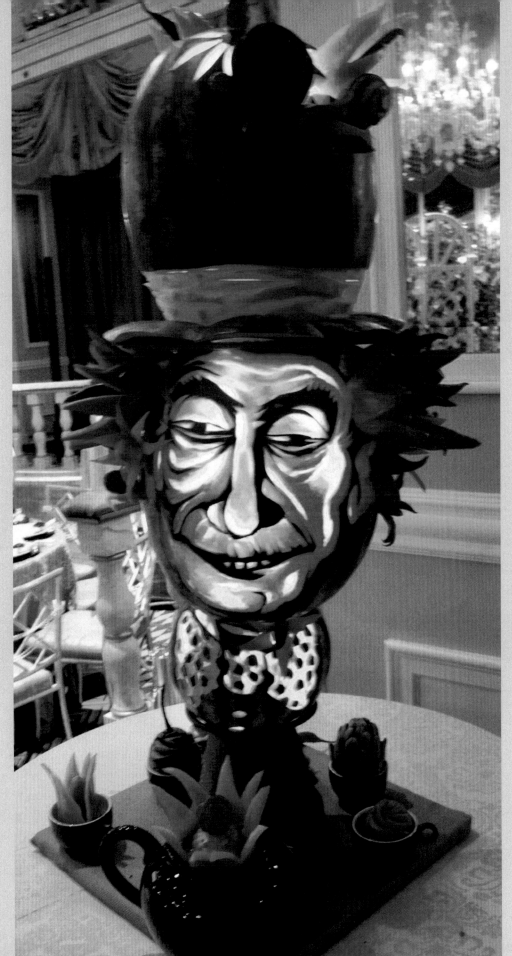

"The Mad Hatter," New York Horticultural Society

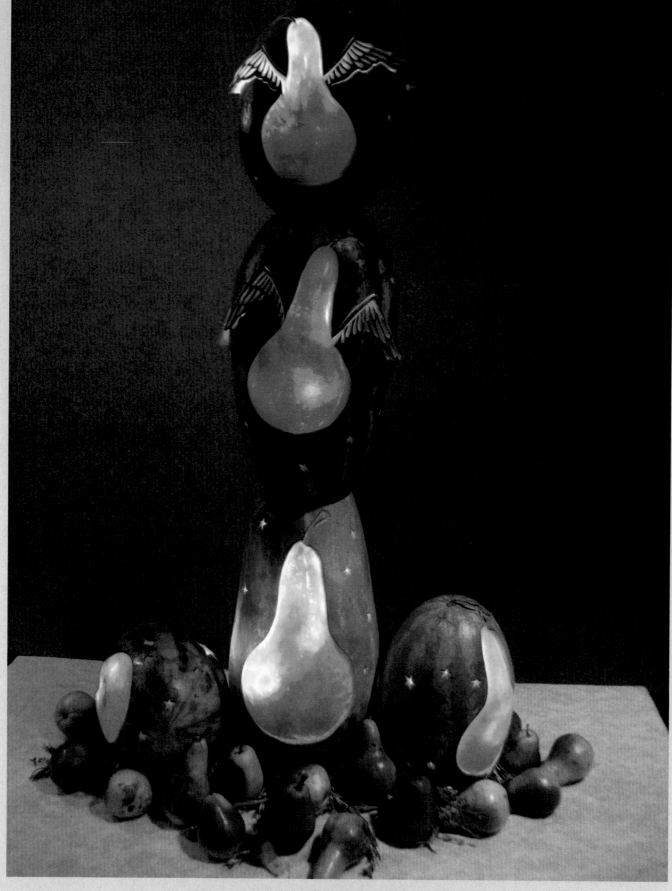

Salon de Culinary Arts

MELONING

A Story of Melon and Pumpkin Carving

Hugh McMahon

with

Michelle Kubota

Noodle Pudding restaurant

Made in the USA
Middletown, DE
21 November 2018